WEB TRICKS AND TECHNIQUES: PHOTO MANIPULATION

ROCKPORT

GLOUCESTER MASSACHUSETTS

< **Web Tricks and Techniques: Photo Manipulation** >

Fast Solutions for Hands-On Web Design

ROCKPORT PUBLISHERS

STEPHEN BEALE

First published in the United States of America by
Rockport Publishers, Inc.
33 Commercial Street
Gloucester, Massachusetts 01930-5089
Telephone: (978) 282-9590
Fax: (978) 283-2742
www.rockpub.com

Library of Congress Cataloging-in-Publication Data
Beale, Stephen.
 Web tricks and techniques: photo manipulation: fast solutions
for hands-on web design / Stephen Beale.
 p. cm.
 ISBN 1-56496-896-0 [pbk.] – ISBN 1-56496-940-1 [hardcover]
 1. Photography—Digital techniques. 2. Websites—Design. I. Title.
TR267 .B43 2002
 005.7'2—dc21 2002004539

10 9 8 7 6 5 4 3 2 1

Design: Peter King & Company
Cover Design: Cross-Media, Inc.

Printed in China

I would like to thank the following people for their assistance:

The Photoshop team at Adobe Systems, who, in addition to creating an amazing piece of software, provided me with early access to Photoshop 7.

Bryn Mooth, Sarah Morton, and Megan Lane, the editors at *HOW* magazine whose assignments kept the groceries coming in as I was writing this book.

My buddies in Sci-Fi, a San Francisco Bay area rock group that has inspired much of my own creative work in Photoshop.

Andy Shalat, who provided some early feedback from a Web designer's perspective, and "graphic sorcerer" Howard Goldstein, my longtime spiritual adviser on all matters related to art and design.

Photoshop gurus Deke McClelland and Bruce Fraser, whose insights into the program over the years have helped me hone my own skills.

And last but certainly not least, Kristin Ellison, Ann Fox, Winnie Prentiss, and the other folks at Rockport Publishers who guided the editing and production of the book.

This book is dedicated to my father, Bruce H. Beale Jr.

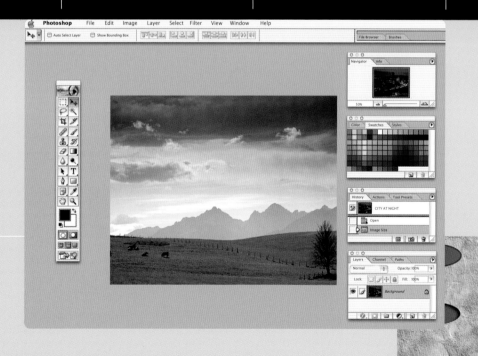

< Contents >

< Introduction >

Of all the software products in the Web designer's toolbox, few play a more central role than Adobe Photoshop. As the name indicates, Photoshop was originally developed as a program for modifying and producing photographic images. But since its introduction in 1990, it has evolved into a powerful, all-purpose graphics tool, equally at home in design firms, photography studios, commercial printing plants, even the production houses that create special effects for movies and television. Whether you're reading a magazine, watching the 11 o'clock news, or, yes, perusing a Web page, there's a good chance that you're seeing Photoshop in action.

>

When the World Wide Web emerged in the mid-1990s as a new mass medium, Photoshop had already established a loyal following among computer-savvy graphic designers. Many thus turned to the program to create ad banners, titles, buttons, backgrounds, and other elements needed to populate the growing number of Web pages. But for all its power, Photoshop had some glaring weaknesses as a Web-production tool, prompting competitors, most notably Macromedia, to develop image-editing programs dedicated to the special requirements of the Web. Adobe responded by giving Photoshop a host of new Web-design functions, some in the program itself, others in a companion product called ImageReady that's included in the Photoshop package. Between the two, designers now have all the tools they need to produce a vast array of graphics for the Web.

However, Photoshop's power carries a price. Although Adobe's engineers have labored mightily to simplify and refine Photoshop's user interface, the sheer weight of features makes the program daunting for novices. The image-editing tools alone can take months to master, not to mention the software's sophisticated functions for handling type and vector graphics. Even experienced Photoshop jockeys might find themselves using just 20 or 30 percent of the features available to them.

That's where this book comes in. Far from being a comprehensive Photoshop guide, it aims to get Web designers quickly up to speed with the features they are most likely to use regularly. By the time you finish, you'll be able to retouch and color-correct photos destined for the Web as well as create your own animated banners, navigation aids—with rollovers—and other common elements. Most important, you'll learn how to create graphics that have maximum impact at minimal file sizes, the primary consideration when producing images for the Web.

We'll begin in chapter 1 with an overview of digital imaging on the Web, discussing the standard bit-mapped graphics formats, such as GIF (Graphic Interchange Format) and JPEG (Joint Photographic Experts Group), and how they differ from vector-based formats such as Flash. We'll consider the role that Photoshop plays in the Web-production workflow and list the new features in Photoshop 7.

In chapter 2, we'll take a quick tour of Photoshop, exploring the tools, menus, and palettes that house the program's many features. We'll also look at Photoshop's layer capabilities—a key part of the program—as well as the new painting engine that was introduced in Photoshop 7.

In chapter 3, we'll cover essential photo-editing techniques, including tonal and color adjustments and the new Healing Brush and Patch tools, which let you remove unwanted artifacts from an image. We'll also show how you can use Photoshop's filter, compositing, and masking functions to create eye-catching special effects.

In chapter 4, we'll use Photoshop to create common graphic elements, including buttons, titles, and backgrounds.

In chapter 5, we'll put the finishing touches on our Web graphics by slicing them, applying image maps, and adding JavaScript rollovers.

In chapter 6, we'll cover basic animation techniques in Photoshop's companion program, ImageReady.

Finally, in chapter 7, we'll discuss the optimization features in Photoshop and ImageReady, which allow you to produce images that look good while consuming minimal file space.

A book of this scope can do little more than scratch the surface of this powerful program. Fortunately, Photoshop invites exploration, and once you become comfortable with its basic features, its advanced functions will seem less daunting. Now let the journey begin.

< Photoshop on the Web >

It goes without saying that the World Wide Web has created vast new opportunities — both economic and creative — for graphic designers. In addition to providing new sources of income, the Web also enables designers to experiment with interactivity and new forms of media, such as animation and video. But as any designer who has worked in this medium will attest, the Web also imposes constraints. Images don't just have to look good, they also have to be bandwidth friendly — that is, compact enough to travel through the narrow pipeline between a Web server and the user's Web browser. Working in print media, you have tremendous control over how images are presented. But when you create graphics for the Web, you need to account for the myriad ways in which people can view them, because each computer system and Web browser renders the images — and the accompanying HTML code — a little differently.

The Web, like earlier technologies such as desktop publishing, has also forced designers to learn new skills, along with new software tools geared for the medium. HTML — the coding system that's the *lingua franca* of the Web — is just the beginning. Many Web designers must also learn basic animation techniques and gain at least a rudimentary understanding of database technologies, as so many Web sites these days are driven by dynamic data. In laypersons' terms, this means that portions of the Web page are generated when you visit the site, and it can alter its presentation based on information you provide.

This doesn't mean that the designer must become a software engineer or database developer — in most cases, you'll be working as part of a team that includes these specialists. But you will have to produce your work in a way that accommodates the needs of Web programmers, and in some situations, especially in smaller design firms, you might find yourself taking on tasks that have more in common with computer science than graphic arts.

1 PHOTOSHOP AND IMAGEREADY

Fortunately, the software tools used to create Web graphics have come a long way in recent years, and this is readily apparent if you've followed the development of Adobe Photoshop, the market-leading photo-editing program from Adobe Systems. Photoshop actually predates the Web; it was originally developed as a tool for preparing photographs and other images for print, a task it still performs with aplomb. But with the explosive growth of the Web, Adobe has adapted the program to meet the increasingly sophisticated demands of Web designers. Photoshop has also gained a companion, a smaller program called ImageReady that's included in the same package.

ImageReady duplicates many functions in Photoshop, and its tools and interface closely resemble those of its sibling. But whereas Photoshop is geared toward production of static images, ImageReady takes those images into the realm of animation and rollovers. Additionally, Adobe has developed both programs to work smoothly with its other Web-authoring tools, notably GoLive and LiveMotion. Thanks to Photoshop's popularity, it also works well with Dreamweaver and Flash, the Web-authoring pro-grams offered by Adobe archrival Macromedia.

ABOVE **Adobe Photoshop has come a long way since its origins as a humble photo-editing tool.**

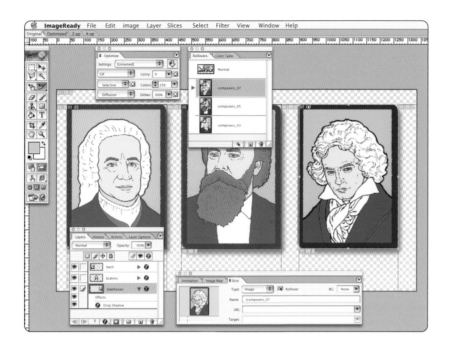

ABOVE **Adobe ImageReady, included as part of the Photoshop package, includes features for creating rollovers, animations, and other special Web graphics.**

In terms of Web-design capabilities, Photoshop hit a milestone with the introduction of Photoshop 6 and ImageReady 3 in fall 2000. The previous release, Photoshop 5.5, was essentially retrofitted to better compete with other programs that were built from scratch to produce Web graphics. In Photoshop 6, new Web-oriented features, such as Layer Styles and vastly improved text capabilities, were smoothly integrated into the program. Photoshop 7, introduced in spring 2001, is a more evolutionary upgrade, but it is the first version of the program that runs natively in Mac OS X, the next-generation operating system from Apple Computer. The software, along with ImageReady, also works with Microsoft Windows as well as Mac OS 9.

2 THE BALANCING ACT

Photoshop is a natural for creating Web graphics because it's primarily geared for production of bit-mapped images, which constitute the vast majority of images you see on the Web. A bitmapped image is an array of dots; in an electronic medium such as the Web, the dots are referred to as *pixels*, a contraction of the term *picture elements*.

Designers who work in print must learn to strike a balance between form and function, creating designs that look good while presenting information in a usable manner. Web designers must also balance form and function but, additionally, they need to consider a third element known as *bandwidth*. Although high-speed DSL and cable modem connections are increasingly popular, most computer users who surf the Web do so through dial-up connections in which data trickles through at a maximum of 56 kilobits per second.

And even a high-speed connection can get bogged down if traffic is heavy or if the Web site is loaded with high-resolution photos or videos. As a result, effective Web design means creating graphics that look good while taking up a minimum of file space.

An image's file size is determined by several factors. The most important are its overall dimensions, generally measured in pixels, and the number of colors it contains. In addition, the file format and compression technique also have an impact on file size. The two most popular formats for Web images are GIF and JPEG, though a third format called PNG is also gaining popularity.

ABOVE **The GIF format is ideal for creating type, buttons, backgrounds, and other graphic elements that require sharp detail. However, it's limited to a maximum of 256 colors.**

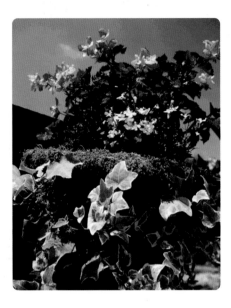 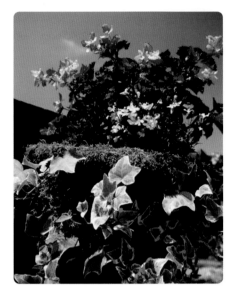

LEFT AND CENTER **Photoshop and ImageReady allow you to optimize GIF files in part by limiting the color palette. The 480-by-600-pixel image on the left includes 256 colors, whereas the version in the middle confines the palette to thirty-two, resulting in more noticeable color-banding effects. Both images are relatively large, consuming 176K and 88K respectively, demonstrating why GIF is generally not the best format for saving photos.**

RIGHT **JPEG is the preferred format for photographs and other images that require a large color palette. This version of the image consumes just 51K when saved at the medium quality setting.**

GIF and JPEG

The GIF format is limited to a maximum of 256 colors, but because it preserves sharpness in edge areas, it's generally used to present nonphotographic elements such as type treatments, logos, buttons, borders, and backgrounds. GIF is also the most popular format for Web animation. Most banner ads you see on Web sites are animated GIF images. Although a GIF image can have up to 256 colors, it can also have fewer than that, and limiting the palette is one method designers use to achieve smaller file sizes. Photoshop and ImageReady both include features that let you reduce the number of colors in a GIF file while having a minimal impact on image quality, a process known as *optimization*.

JPEG is the preferred format for photographs, fine art, and other images that require a large color palette. It uses what's known as a lossy form of compression, meaning that it reduces file sizes in part by selectively throwing away the data that constitute the image. When you save a JPEG file in Photoshop or other programs, you have the option of determining the degree of compression. If you choose a low degree of compression, the software removes a minimum of data; the result is a high-quality image, but one with a relatively large file size (though still considerably smaller than you'd get with an uncompressed format such as TIFF or PICT). If you choose a high degree of compression, the software removes a greater amount of data; the result is a smaller file and lower image quality, often seen in the form of blocky image artifacts, especially in areas with sharp edges.

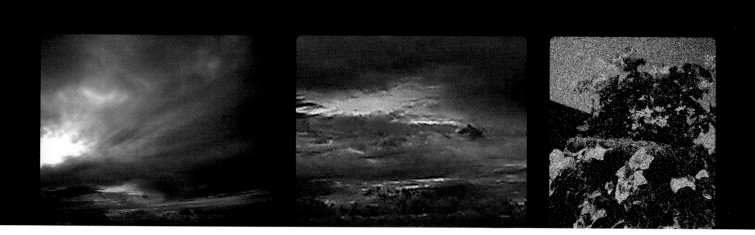

Beyond the compression ratio you choose, the content of the image also determines how much it will be compressed. If the image has broad areas with similar colors, such as a big blue sky, it will compress more easily than one that has a lot of noise or fine detail. Here again, Photoshop and ImageReady have features that let you strike the best possible balance between file size and image quality.

The PNG format offers advantages over GIF and JPEG, but it's not supported in all Web browsers, especially early ones. The format comes in two flavors, PNG-8 and PNG-24. PNG-8 can be thought of as an alternative to GIF; it's limited to 256 colors but, thanks to its superior compression technique, the files are about 30 percent smaller. PNG-24 combines the best features of GIF and JPEG, offering the sharpness of the former and the broad color range of the latter, making it suitable for almost any kind of image, including photographs. However, because it uses a lossless compression technique, the files tend to be larger than the equivalent JPEG files.

We'll discuss these formats in greater detail in chapter 7.

LEFT AND CENTER **This stormy sky looks fine when saved with a medium JPEG setting, but with too much compression, you begin to see blocky JPEG artifacts. JPEG artifacts are even more noticeable in images with sharp edge detail, as we'll see in chapter 7.**

RIGHT **Images with a lot of noise or fine color detail don't compress as well as those with broad areas of the same color. When we apply a Mezzotint filter effect to this image, it balloons to 120K when saved with medium JPEG compression versus 51K for the original.**

Vector Graphics

Although most images seen on the Web are bit-mapped, some originate in vector formats, which are also referred to as *object-oriented graphics*. The best-known example of a vector format is Flash, which was pioneered by Macromedia; another is the Scalable Vector Graphics (SVG) format championed by Adobe. Unlike bitmapped graphics, which are built from pixels, vector graphics are built from lines and curves. The graphics are rendered on screen as pixels, but they are stored internally as compact mathematical expressions.

Vector graphics are ideal for presenting type, logos, diagrams, maps, technical illustrations, and other elements composed of lines and curves. These are the kinds of graphics produced by Adobe Illustrator and Macromedia FreeHand, though Photoshop also includes a set of vector-graphics tools.

Because GIF and JPEG are such well-established standards, almost all Web browsers, including Internet Explorer and Netscape Navigator, have built-in features for rendering them. Flash, in contrast, is one of many Web formats that must be viewed through a browser plug-in, which you can download for free from Macromedia's Web site. Fortunately for Flash authors, it's an extremely popular format, and most users have the plug-in needed to view it. Macromedia Flash is the most popular program for producing Flash animations, but you can also create them in Adobe's LiveMotion and other software. Flash and LiveMotion can both import Photoshop files and LiveMotion can even work with individual layers within those files. Although Flash and SVG are primarily vector formats, they can incorporate bitmapped images as well. Unlike Flash, which is owned and controlled by Macromedia, SVG is an open industry standard managed by W3C, the same group that developed the HTML standard. It is based on the Extensible Markup Language (XML), another open standard that's become increasingly popular on the Web. Flash and SVG each have advantages and disadvantages, though Flash is by far the more popular format.

A Multitude of Applications

Here are some of the ways in which Web designers can use Photoshop:

- Preparing photographs and illustrations for deployment on the Web, including retouching and application of special effects.

- Creating digital paintings and illustrations.

- Creating static or animated banner ads that include text and graphics.

- Creating headlines and other stylized text treatments.

- Creating buttons, borders, background tiles, and other graphic elements. You can add Web links — URLs — to these and other graphics created in Photoshop, then open the files with links intact in Adobe GoLive.

- Creating rollovers and animations.

- Creating online photo galleries.

- Preparing files for use in vector-animation programs, such as Macromedia Flash and Adobe LiveMotion.

- Producing prototypes of Web pages that are then constructed in a Web-authoring program such as Adobe GoLive or Macromedia Dreamweaver. GoLive and Dreamweaver users can import files created in Photoshop as templates, employing them as guides for building a Web page.

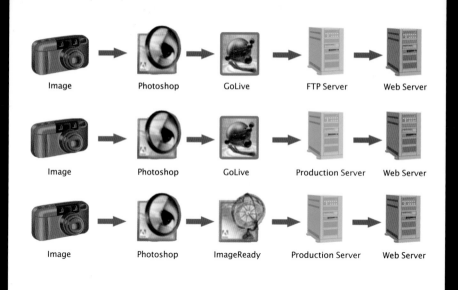

| Image | Photoshop | GoLive | FTP Server | Web Server |

| Image | Photoshop | GoLive | Production Server | Web Server |

| Image | Photoshop | ImageReady | Production Server | Web Server |

ABOVE **Web designers can use a variety of workflows depending on the nature of the project. It might be as simple as preparing images and Web pages for upload to an FTP site (top row) or a more complex workflow in which images are transferred to a Web-production server for incorporation into a data-driven Web site (middle row). If the project includes animations, image maps, or rollovers, then Adobe ImageReady plays a role in the process (bottom row).**

The Web-Production Workflow

The workflow you use to create images in Photoshop depends largely on whether you are designing exclusively for the Web or simultaneously for the Web, print, and other media such as digital video. It also depends on what kind of site you plan to produce.

If you're a solo designer producing a relatively simple Web site, you'll most likely use Photoshop to produce GIF, JPEG, or PNG images, then import those images into a Web-authoring program such as GoLive or Dreamweaver. If you find that you need to make further modifications to the image, you can launch Photoshop from directly within GoLive or Dreamweaver and make the changes. When you close the image in Photoshop, the changes are automatically incorporated into the Web page.

If you're working as part of a team to produce a large, data-driven Web site, you may not work in a Web-authoring program at all. Instead, you'll produce the images in Photoshop and upload them to a server, where they'll be automatically processed and incorporated into a Web-production system. Photoshop supports a popular interchange protocol called WebDAV that provides a structured way to check files in and out of a Web-production system.

If you're working in multiple media, such as print and Web, you'll need to account for the different needs of each medium. Images destined for print require much higher resolution than those destined for the Web, and you'll generally be using a different image format, most likely TIFF, instead of GIF or JPEG. A common approach here is to begin with high-resolution images suitable for print, then save copies of the files in GIF or JPEG format for deployment on the Web. You can also use Photoshop's batch-processing function to convert a folder full of high-resolution Photoshop or TIFF images into smaller, 72-dpi GIF or JPEG files.

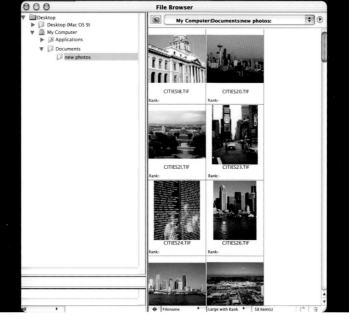

If your Web-production system includes Adobe's AlterCast software, you won't be producing GIF or JPEG images at all. Instead, you'll be submitting Photoshop files that include variable text or image layers. AlterCast allows programmers to develop sophisticated production systems capable of customizing Photoshop files on the fly. For example, visitors to a Web site for an auto dealer can enter their name and the car model they want to check out. AlterCast can insert the visitor's name and a photo of the car directly into the Photoshop file, then automatically generate an optimized JPEG image that's displayed on the Web site. In this kind of setup, you'll need to work with the programmers or production personnel to determine how the Photoshop files should be set up and submitted.

Companion Software

It's the rare Web designer who can get away with using a single piece of software, even one as sophisticated as Photoshop. In addition to the Web-authoring and animation programs described previously, a Web designer might also have occasion to use an image-database program, such as Canto Cumulus or Extensis Portfolio, to store large volumes of images. These programs include features that let you assign keywords to images, and then use those keywords to access the images as needed. Photoshop 7 lacks image-database capabilities, but it does offer the next best thing in the new File Browser, which lets you search through folders and display thumbnail versions of the images contained within.

ABOVE **Photoshop's new File Browser lets you view and organize images on your system.**

Photoshop itself can be enhanced in many ways through the use of plug-ins—utility programs that add new capabilities to the program. For example, numerous developers offer collections of special-effects filters that go far beyond the filters included in the base program. Popular examples include the Andromeda filters from Andromeda Software, the KPT filter collections from Corel's Procreate division, and Eye Candy 4000 and Xenofex from Alien Skin Software.

Other plug-ins allow you to save images in file formats not otherwise supported in Photoshop, such as LizardTech's MrSID and LuraTech's LuraWave. These formats offer better image quality and higher degrees of compression than JPEG, but visitors to a Web site must download special browser plug-ins to view the images.

Web designers using Photoshop should also have access to all of the popular Web browsers on both Windows and Macintosh platforms. Each browser and computer system displays Web graphics a little differently, so it's a good idea to proof your work on a variety of systems. Although Microsoft's Internet Explorer is by far the most popular browser for the Mac and Windows, many use Netscape Navigator or America Online's browser, which is based on Internet Explorer. Other browsers include Opera, iCab, and OmniWeb. In addition to proofing your work with the latest versions of the most popular browsers, it's often smart to test earlier versions as well, because many Internet users are slow to upgrade. You don't need to go overboard, though; while a few users may still be stuck with IE 3 or Navigator 3, they probably aren't numerous enough to warrant testing your work on these programs.

3 PHOTOSHOP 6 VERSUS PHOTOSHOP 7

Photoshop 6 represented a major leap in the program's Web-production capabilities. Photoshop 7 is a more evolutionary upgrade, but it still includes many compelling new features. The most important of these, at least for Macintosh users, is its ability to run natively in Mac OS X, Apple Computer's new operating system.

Mac OS X is a radical departure from earlier versions of the Mac OS. Based in part on the powerful Unix operating system, it offers all the features of what's known as a modern OS. These include pre-emptive multitasking, which allows multiple programs to more efficiently share the CPU, the chip that is the brain of any computer system.

Its protected memory feature allows each program to run in a separate memory space, unlike the classic Mac OS, where programs share memory. If a program crashes in Mac OS 9, it usually brings down the entire system with it, and you have to reboot the computer. With OS X's protected memory, a program that crashes won't affect other applications and the system itself won't freeze. OS X also offers a sophisticated virtual memory system that dynamically assigns memory to each program as needed. In Mac OS 9 and earlier versions of the Mac OS, you must allocate a certain amount of memory to each program. This is no longer necessary in Mac OS X. Finally, Mac OS X includes sophisticated multiprocessing features, so programs that run under it can take better advantage of Mac systems that include multiple CPUs.

The new Mac OS also looks different in that it uses a colorful, new user interface known as Aqua. Aqua has aroused controversy among Mac users because it departs in many ways from the features they've grown accustomed to in previous versions of the Mac OS. When Apple first released prototypes of the system, some designers complained that its colorful interface features distracted them from their work. However, Apple has added the ability to switch to an alternative color scheme in which many of the interface features appear in gray.

Photoshop 6 can run in Mac OS X, but only in what's known as the Classic environment, a version of Mac OS 9 that runs within OS X. When you run a program in the Classic environment, you can't take advantage of the modern OS features described previously.

Beyond its ability to run in Mac OS X, Photoshop 7 includes other new features:

- A new painting engine that allows you to create a much wider range of painting effects, including those designed to mimic real-life painting tools.

- A redesigned Rollovers palette, plus a new Selected state for JavaScript rollovers.

- The Healing Brush and Patch tool, designed to remove scratches, noise, and other unwanted artifacts from images.

- Spell-check and find-and-replace functions for use with Photoshop's text features.

- New blending modes for layers and painting tools, which let you determine how they interact with the underlying image.

- The aforementioned File Browser, which lets you search for and display images stored on the computer system.

- The ability to save a particular arrangement of tools and palettes in the workspace for reuse.

- A new Tool Presets palette that provides quick access to all of the program's tools.

- The Pattern Maker, which makes it easier to create and preview patterned backgrounds from existing images.

- An Auto Color function that automatically fixes the colors in an image.

- A Histogram function that displays information about the tonal range of an image. This is separate from the Levels function, which also includes a histogram display.

- An expanded library of built-in shapes for use with the Custom Shape tool.

- A redesigned Layers palette in which you can define the fill transparency of a layer separately from its overall transparency.

We'll describe many of these features in greater detail in the chapters that follow.

ABOVE **The Graphite color scheme in Mac OS X was designed to make the Aqua interface less distracting for graphic artists.**

4 HARDWARE CONSIDERATIONS

Photoshop, as we've noted, works on Macs running the Macintosh OS and PCs running Microsoft Windows. However, for a number of technical reasons, it tends to run faster on the Mac, even models that have lower megahertz (MHz) or gigahertz (GHz) ratings than comparably priced PCs. One reason for this is the Velocity Engine, a key feature of the PowerPC G4 processor, the chip that drives higher-end Macs aimed at professional users. Photoshop has been written to take advantage of the Velocity Engine's ability to accelerate certain software functions, so you'll get the best performance on a G4 system. The G3 chips in Apple's consumer-oriented iBook and first-generation iMac do not include the Velocity Engine, but even though Photoshop doesn't run quite as fast on these systems, many users find its performance even here to be acceptable, especially when running under Mac OS 9. Although Mac OS X runs on most G3 Mac systems, it performs much better on the G4, in part because many of its functions are tuned for the Velocity Engine. Apple's Titanium PowerBook, desktop Power Mac, and new LCD-based iMac all sport G4 processors.

Chip speed is only one of several factors that affect Photoshop performance. Another important factor is the amount of random-access memory (RAM) that you've installed. In general, the more RAM, the better; you'll need a minimum of 128MB on the Mac, but 256MB or more is preferred. Extra RAM is especially useful when you're working with high-resolution images. This is less of a factor in Web design than it is with other Photoshop applications because you'll generally be working with relatively low-resolution images. Nevertheless, if you want to be productive when using Photoshop, it pays not to skimp on the hardware.

If you want to maximize your productivity in Photoshop, it's also a good idea to use a large-screen monitor, one with a diagonal measure of at least 19 inches. This is not just a matter of displaying large images; many Photoshop functions are accessed through palettes that take up precious real estate on the screen. With a large-screen monitor, you can have more palettes open at the same time without getting in the way of the image. In almost all cases, the display should be set to show "millions" of colors (the actual number is about 16.7 million, or 24 bits) so that you can accurately view photographs. If it's set to "thousands" (16 bits), you're likely to see banding in areas of the image that have smooth gradations. The only exception to this rule is if you want to proof your work as it will appear on a 16-bit display. Many older PCs are limited to displaying 8 bits (256 colors), though they're increasingly rare.

Another consideration with displays is whether to use a CRT or LCD. LCD monitors, which take up much less desk space while offering a crisper, flicker-free display, have become more popular as their prices have fallen; they're the only kind that Apple sells now. However, most users still have CRTs, which tend to be cheaper. Though Apple no longer sells CRTs, many companies offer CRT models that work with the Mac.

Either way, you should be sure that the monitor is calibrated to show colors as accurately as possible. Apple includes a simple calibration utility as part of the Monitors control panel in Mac OS 9 and System Preferences (Displays) in Mac OS X. If precise color reproduction is especially important to you, several companies offer more elaborate calibration products. Keep in mind, however, that color management is an inexact science, and even calibrated systems often display the same colors somewhat differently.

Assuming that you have your hardware in order, it's now time to take a quick tour of the features in Photoshop 7.

LEFT **The 22-inch Apple Cinema Display from Apple Computer uses LCD technology. (Courtesy of Apple Computer.)**

< A Quick Tour of Photoshop >

Adobe Photoshop is a complex piece of software, and an exhaustive description of its features is beyond the scope of this book. However, in this chapter, we provide a quick overview of the program's functions, focusing primarily on those of interest to Web designers. But first, we'll look at what you'll be creating in Photoshop, namely the Photoshop file.

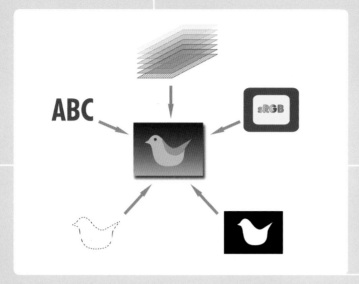

1 ANATOMY OF A PHOTOSHOP FILE

Once upon a time, a Photoshop file—identified by the extension .PSD—was just one of many bitmapped image formats, like TIFF and PICT. However, as Photoshop has evolved over the years, so has the Photoshop file. In versions 6 and 7, a Photoshop file can include multiple layers containing bit-mapped images, editable text, or editable vector graphics. It can include adjustment layers that don't have any content of their own but modify the appearance of the layers underneath. It can include clipping paths or alpha channels that define which portions of the image are visible and which are transparent. It can include color profiles, which, when used in conjunction with color-management software, such as Apple's ColorSync, ensure consistent color reproduction across different monitors and output devices. And it can include metadata, which provides information about the content of the file.

As a Web designer, you'll most likely be converting Photoshop files into the much simpler JPEG or GIF formats, using Photoshop's *File->Save As* command to do so. However, you should generally retain your work in the Photoshop format, preserving the

text, layers, and other elements, then saving out GIF or JPEG files as needed. Photoshop files may be complex beasts, but the format lends the program a great deal of flexibility. For example, any text in a GIF or JPEG file will be rasterized—that is, converted to a bitmap. If you find a typo or otherwise need to change the text, you have little choice but to re-enter it from scratch. However, if you retain the original text layers in the Photoshop file, you can go back and easily make any changes, then save the file again as a GIF or JPEG image.

Photoshop's multilayered structure also lends itself to creation of animations and other common Web design elements. For example, ImageReady, Photoshop's companion program for producing Web graphics, can automatically convert vector or bitmapped layers into animation frames, rollover states, or image slices. If you import a layered Photoshop file into Adobe LiveMotion, you can convert each layer into a separate object that's independently moved, rotated, or resized.

LEFT **A Photoshop file can incorporate multiple layers of various kinds, along with a color-management profile, alpha channels, clipping paths, and editable type.**

2 THE PHOTOSHOP WORKSPACE

The Photoshop workspace consists of the main canvas, Toolbox, Options bar, menu bar, and an assortment of palettes: Brushes, Swatches, Layers, Channels, and so on.

The Toolbox provides access to Photoshop's selection, painting, and other tools. It displays twenty two tools at a time and offers access to additional ones through small pop-up menus that appear when you hold down the mouse button over certain tool icons. We'll discuss the toolbox in great detail later in this chapter.

The Options bar, just below the main menu bar, presents the options for the tool or command you've selected. For example, if you select the Type tool, the Options bar provides controls for font, type size, alignment, and other settings.

The palettes, which you open through the Window menu, are modeless, meaning that you can access their features at any time. Along with the tools in the palette, each has its own menu that provides access to relevant features. In many (but not all) cases, the palette menus duplicate commands that are found in the main menus. For example, many commands in the Layers palette menu are also in the Layer menu. Small icons along the palette's lower border provide access to frequently used commands. For example, you can delete a layer by clicking on the small trash can icon that appears in the Layers palette.

LEFT **The Photoshop workspace consists of the menu bar, Options bar (just below the menus), main canvas (center), Toolbox (left), and an assortment of palettes (right).**

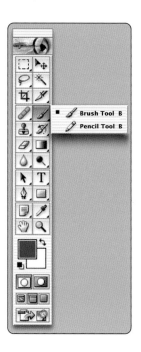

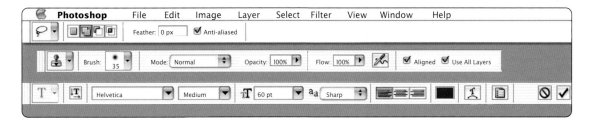

To keep the workspace from becoming needlessly cluttered, you can drag palettes into groups or into the dock that appears on the right side of the Options bar. To drag a palette, move the mouse to the palette's tab, hold down the mouse button, and drag. If the palettes are grouped, the last palette you used appears in front. To bring another palette to the front, just click on its tab.

Photoshop 7 includes a helpful new feature, *Window->Workspace->Save Workspace*, that lets you save a particular workspace for reuse. When you save the workspace, Photoshop remembers which palettes are open, how they are grouped, and how they are positioned. For example, you might have one workspace optimized for creating banner ads and another for photo retouching. You can then quickly call up the appropriate workspace depending on the job. If multiple users are working with the same copy of the program, each can save a custom workspace according to his or her own preferences.

LEFT **Some of the tools in Photoshop's Toolbox, such as the Brush and the Pencil, share the same location. A small arrow in the corner of the icon indicates the presence of additional tools. Hold down the mouse button to see their names.**

RIGHT **The Options bar presents different options depending on which tool is selected. Shown here are options for the Lasso, Clone Stamp, and Type tools.**

3 PHOTOSHOP'S MENUS

Photoshop Menu

This menu appears only in the Mac OS X version of Photoshop. It provides access to features that apply to the program as a whole rather than to individual documents. In Mac OS 9, these features are scattered among several other menus: File and Edit within Photoshop as well as the Apple Menu and Application Switcher in Mac OS 9. A new Mac OS X feature called Services lets you access systemwide resources, such as screen captures and e-mail, from within the program.

File Menu

This menu provides access to Photoshop's file-management, automation, and printing functions. Use these features to create new files or to open, save, or print existing ones.

The Automate submenu includes features for creating contact sheets and running batch operations on multiple files. The batch feature is especially powerful in conjunction with Photoshop's Actions. For example, you can set up an Action that converts images to 72-dpi resolution and saves them in JPEG format. Using the batch feature, you can then apply that Action to a folder full of images. The Web Photo Gallery feature automatically creates Web pages containing thumbnail or full-sized versions of each image in a folder. You can choose from a variety of preset layout styles.

The Workgroup submenu, new in Photoshop 7, offers features that let you upload and download images from sophisticated workgroup collaboration systems such as Adobe's InScope and DesignTeam.

Jump To lets you quickly launch ImageReady, a companion program used to create animations, rollovers, and other effects commonly used with Web graphics.

ABOVE **The Photoshop menu.**

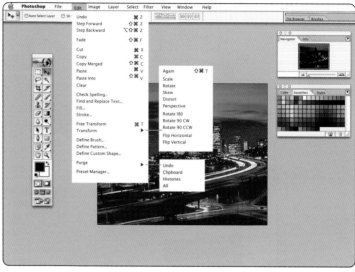

Edit Menu

This menu includes features for editing layers and selections in Photoshop files, including cut and paste, scaling, and rotation. New in Photoshop 7 is the ability to perform spell-check and find-and-replace operations on text.

When you make a selection in an image, Transform options allow you to scale, rotate, and spatially distort the area within the selection. You can use the same commands to transform vector graphics created in Photoshop.

Use the *Edit->Transform->Again* option to repeat a transformation, either on the same selection or a new one. For example, if you scale one item to 50 percent of its original size, you can use this command to quickly scale another object by the same amount.

LEFT **The File menu.**

RIGHT **The Edit menu.**

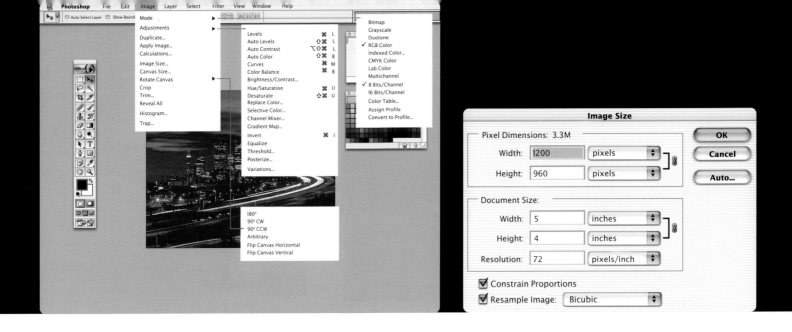

LEFT **The Image menu.**

RIGHT **The Image Size dialog box lets you change the dimensions or resolution of an image. If the image is intended solely for the Web, you should set the resolution to 72 dpi.**

Image Menu

Plan to spend a lot of time in the Image menu, especially if you intend to work with photographs. This is home to Photoshop's primary photo-retouching functions, along with features for modifying the image size, resolution, and other settings.

Mode provides commands that convert the image to RGB, CMYK, Indexed Color, and other color spaces (see Working with Colors, page 52).

The Adjustments submenu (known as Adjust in Photoshop 6 and earlier versions) includes features for modifying the tone and color of images. We'll discuss these in greater detail in chapter 3.

Use Image Size to reduce or enlarge an image or to change its resolution; for Web work, you should convert images to 72 dpi. When enlarging an image, Photoshop uses a technique known as interpolation in which it intelligently adds new pixels between the existing ones. If you limit the enlargement to 200 percent or so, you'll get reasonably good results with many images, though you're almost always better off if you begin with a larger image rather than scaling it up.

Use the canvas Size option to increase or reduce the size of the canvas, the area in which the image resides. If you increase the canvas size, a border will appear around the image. If you decrease it, the image will be cropped (you can also use the *Image->Crop* command or the Crop tool to perform cropping operations). If the new canvas size is smaller than the current one, Photoshop gives you a friendly warning to be sure you want to proceed. Use Trim to remove white or transparent areas surrounding an image.

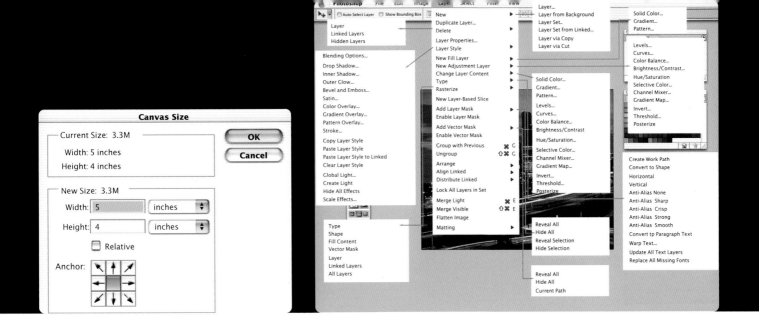

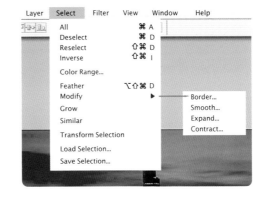

Layer Menu

This menu provides access to Photoshop's extensive layer options. Some, but certainly not all, of the commands are duplicated in the Layer palette and Styles palette menus. Using the commands here, you can create new layers of various kinds, apply masks or clipping paths to layers, convert type or vector layers into rasterized bitmaps, and flatten the image so everything appears on a single background layer (see Working with Layers, page 61).

Select Menu

Use this menu to save, load, and modify selections. We'll discuss it in greater detail when we cover Photoshop's selection tools next.

ABOVE LEFT **Use the Canvas Size command to reduce or enlarge the size of the canvas. Click on one of the tiles in the grid to determine where the current image should be located within the resized canvas. If you set a size smaller than the current canvas, Photoshop crops the image from the sides indicated by the arrows.**

ABOVE RIGHT **The Layer menu.**

LEFT **The Select menu.**

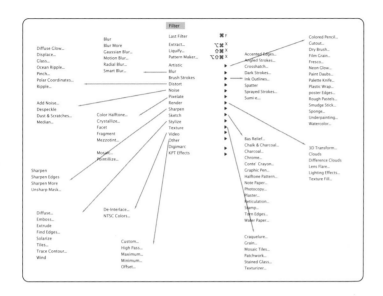

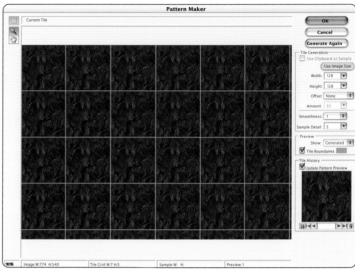

LEFT **The Filter menu.**

RIGHT **The Pattern Maker function lets you create and preview tiled backgrounds.**

Filter Menu

This menu provides access to Photoshop's built-in filters as well as any third-party filters that you've added. In Photoshop 7 it also includes the Liquify and Extract plug-ins that were previously found in the Edit menu.

You can think of Liquify as a miniature painting program that lives inside Photoshop. It treats the image as if it's floating on a pool of water, providing tools that let you distort the image in numerous ways. Extract allows you to mask portions of an image whose boundaries would otherwise be difficult to select, such as hair and fur. This menu also provides access to Photoshop 7's new Pattern Maker function, which lets you create reusable patterns.

The filters in the menu are divided into thirteen categories based on their function: Artistic, Blur, Brush Strokes, Distort, Noise, Pixelate, Render, Sharpen, Sketch, Stylize, Texture, Video, and Other. Third-party filters are displayed on the bottom. The *Filter->Last Filter* command repeats the last filter you applied. You can also use the *Edit->Fade* command to moderate the filter effect.

View Menu

This menu provides access to commands that let you control the image display and workspace. For example, you can display rulers, zoom in and out, add rules to use as guides, show or hide the grid or image slices, and set snapping options. When Snap is selected, any objects that you add or move automatically snap to the nearest guide or grid line.

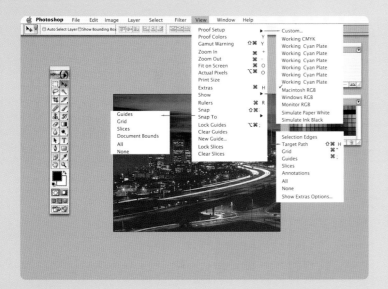

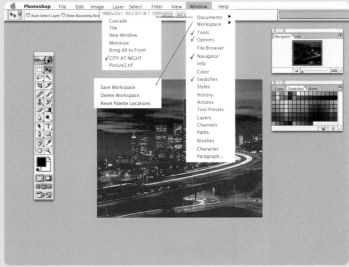

Window Menu

This menu lets you determine which palettes are shown or hidden. Additionally, you can bring other open documents to the frontmost window and save the current workspace.

Help Menu

This menu, in addition to providing access to Photoshop's online help system, also includes wizards that guide you through the process of resizing the image or exporting an image that includes transparency. It also includes a link to the Adobe Web site. The online help system is implemented through a Web browser that automatically launches when you choose the *Help->Photoshop* Help command.

Help	
Photoshop Help...	⌘?
Export Transparent Image...	
Resize Image...	
System Info...	
Updates...	
Support...	
Registration...	
Adobe Online...	

ABOVE LEFT **The View menu.**

ABOVE RIGHT **The Window menu.**

LEFT **The Help menu.**

Toolbox Diagram

Left labels	Right labels
Marquee selection tools	Move tool
Lasso selection tools	Magic Wand
Crop tool	Slice/Slice Select tools
Heal Brush/Patch tool Clone	Brush/Pencil tool
Stamp/Pattern Stamp	History Brush/Art History Brush
Eraser tools	Gradient/Paint Bucket tools
Blur/Sharpen/Smudge tools	Dodge/Burn/Sponge tools
Path Select tools	Type tools
Path creation tools	Shape tools
Notes tools	Eyedropper/Measure tools
Pan tool	Zoom tool
	Foreground/Background colors
Normal/Quick Mask toggle	
	Display mode
Jump to ImageReady	

4 THE TOOLBOX

The Photoshop Toolbox provides access to selection, painting, vector, text, and other tools. To keep it to a manageable size, Photoshop groups some of the tools in the same locations, with a small arrow in the lower right corner indicating the presence of additional tools. For example, if you move the mouse over the Brush tool icon and hold down the mouse button, a small menu appears, letting you choose either the Brush or the Pencil tool. If you choose the Pencil tool, its icon replaces the Brush tool icon in the toolbox. In a similar way, the Rectangular Marquee selection tool provides access to the Elliptical Marquee tool along with tools for selecting rows or columns.

Below the tools are overlapping squares that indicate the currently selected foreground and background colors. The foreground color applies when you choose the Brush, Pencil, Type, and other Photoshop tools. Photoshop provides several ways to choose the foreground or background colors: You can select a color from the Swatches or Colors palettes (see below), or use the Eyedropper tool—also described below—to sample a color from the image. Or you can double-click on one of the squares to open Photoshop's Color Picker (see Working with Colors, page 51).

Underneath the overlapping squares are two icons that let you choose between standard editing mode and Photoshop's QuickMask mode (see Selections, Masks, and QuickMask, page 37).

LEFT **The Toolbox provides access to selection, painting, vector, and type tools. You can also set the display mode and choose the foreground and background colors. Some tools are grouped in the same location.**

TOP RIGHT
Foreground/Background color indicator.

BOTTOM RIGHT
Standard/QuickMask editing mode.

Selections, Masks, and QuickMask

When you make a selection in Photoshop, you create what's known as a mask. A mask functions like a digital stencil, restricting most image-editing operations to the area within the selection. Because masks are essential to many Photoshop operations, the program provides several ways to create them. One of these is the QuickMask mode, which lets you use painting tools instead of— or in combination with—selection tools to create a mask.

In Photoshop's standard editing mode, you create or modify selections with the selection tools, and the selections appear with the familiar marching ants outline. In QuickMask mode—accessed by clicking on the QuickMask icon in the Toolbox or by typing Q—you create or modify selections using the painting tools. Masked areas—the parts outside the selection—appear in red. You can paint over the areas you want to mask or use the Eraser tool to paint over areas you want to reveal. If you toggle back to standard mode by clicking on the Edit in Standard Mode icon, the masked areas are again identified by the marching ants outline.

The mask you create in QuickMask mode is temporary. It remains only as long as there's a current selection, unless you save it as an alpha channel using the *Select->Save Selection* command. We'll discuss masks in greater detail in chapter 3.

LEFT **In Standard Editing mode (top), you modify selections using selection tools such as the Rectangular Marquee. In QuickMask mode (bottom), selections are converted into masks that you can modify with Photoshop's Brush, Pencil, and Eraser tools.**

ABOVE **QuickMask icon.**

LEFT **Display Mode buttons.**

CENTER **Jump to ImageReady button.**

RIGHT **You can modify Photoshop selections by adding to an existing selection (indicated by the squares on the left), by subtracting from an existing selection (middle), or by intersecting an existing selection (right). Selected areas are shown in green, unselected areas in red.**

Display Mode buttons let you choose among three display modes: Standard Screen mode, in which the windows float above the Mac or Windows user interface; Full Screen mode with Menu Bar, in which Photoshop takes over the screen; and Full Screen mode, in which Photoshop takes over the screen and drops the menu bar. On the bottom of the Toolbox is an icon that lets you jump to ImageReady, Photoshop's companion program for creating rollovers, animations, and other effects.

Selection Tools

Use these tools to make or modify selections in a bit-mapped image. Once an area is selected, most subsequent actions will apply only to the portion of the image within the selection. You can also use selections to create masks, move part of an image elsewhere, or perform cut-and-paste or copy-and-paste operations. We'll discuss masks in chapter 3.

Once you have a selection, you can add to or subtract from it by making additional selections. To add to a selection, hold down the shift key—or click on the Add to Selection icon in the Options bar—and make a new selection. To subtract from a selection, hold down the Option key—or click on Subtract from Selection—and make a new selection that overlaps with the original one; the overlapped area is removed from the original selection. You can also create an intersection between the first selection and the second one.

- ■ [] Rectangular Marquee Tool M
- ○ Elliptical Marquee Tool M
- ▭ Single Row Marquee Tool
- ▯ Single Column Marquee Tool

As an alternative to these tools and commands, you can use Photoshop's QuickMask mode to paint over the areas you want selected or deselected (see page 37).

Photoshop's Select menu provides numerous commands for working with selections. For example, you can use the *Select->Modify->Contract* command to reduce the selected area by a specified number of pixels or the *Select->Modify->Expand* command to expand the selected area. Use the *Select->Similar* command to choose portions of the image with the same color as the selected area. Use the *Select->Inverse* command to invert the selection so that the previously unselected portions are selected and vice versa.

Because so many operations depend on Photoshop's selection tools, mastering them is essential to using the program productively.

MARQUEE SELECTION TOOLS Use these tools to make rectangular or elliptical selections. For rectangular selections, position the mouse in one corner of the area you want to select, then drag to the opposite corner while holding down the mouse button. Elliptical selections work in a similar manner, except the selection will be an ellipse that appears within the boundaries that you've defined by dragging the mouse. To make a perfect square or circle, hold down the Shift key as you drag.

When the Style option in the Options bar is set to Normal, you can make selections of any dimensions you choose. Alternatively, you can use the Fixed Aspect Ratio or Fixed Size options to confine selections to a specified aspect ratio or size.

The Single Row Marquee or Single Column Marquee tools, also available in this toolbox location, let you select a row or column that's one pixel wide.

ABOVE **Marquee Selection tools.**

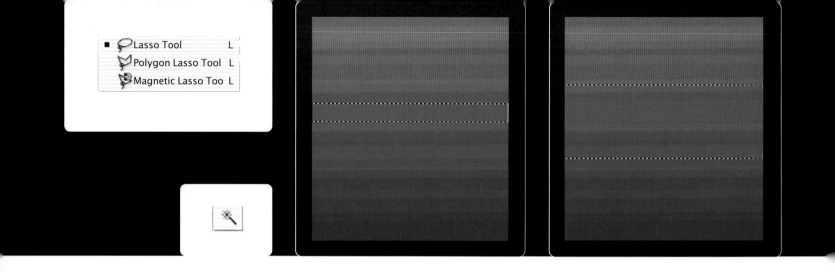

LEFT **Lasso tools.**

RIGHT TOP **Magic Wand.**

RIGHT CENTER **When you click in an area with the Magic Wand, it automatically selects all adjacent pixels with similar color values. Here, we set the Tolerance to a low value, so the Magic Wand selected a narrow range of colors.**

RIGHT BOTTOM **Here, we set the Tolerance higher, so the Magic Wand selected a wider range of colors.**

LASSO TOOLS The Lasso tools let you select areas with irregular boundaries. You can also use them in conjunction with the Marquee or Magic Wand tools. The basic Lasso tool lets you draw free-form selection boundaries. The Polygon Lasso tool lets you create selections whose boundaries consist of straight lines.

The Magnetic Lasso tool is an intelligent version of the Lasso that recognizes boundaries between adjoining areas in the image. As you draw a selection, the Magnetic Lasso automatically snaps to the nearest boundary. It's a potential time-saver because you don't have to be as precise when making the selection. It works best when selecting regions that have a high degree of contrast with surrounding areas.

MAGIC WAND This tool is great for selecting solid colors—or areas with similar colors—within an image. You just click once inside a region, and the tool automatically selects all contiguous areas that have the same or similar colors. The Tolerance setting in the Options bar determines the range of colors that the tool will select. If you set Tolerance to a low value, it will select only contiguous areas that closely match the color on which you click. If you set a higher value, it will select a broader range of colors.

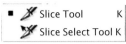

CROP TOOL Photoshop provides several methods for cropping images; this is probably the easiest. Use it to draw a rectangle around the portion of the image you want to keep. You'll see handles around the edges; drag on these to change the area to be cropped. When you're ready to crop the image, double-click within the selected area or click on the check mark in the Options bar.

Alternatively, you can use the Rectangular Marquee to select the area of the image to keep, then choose *Image->Crop* to crop out the rest. You can also use Photoshop's *Image->Canvas Size* command to crop an image to a specified set of dimensions.

SLICE/SLICE SELECT TOOLS As you prepare an image for the Web, it may be necessary to slice it. Slicing an image is useful if you want to employ rectangular areas as navigation aids or if you want to apply different compression or color-reduction settings to different parts of the image. A slice can contain a URL and it can be used as a basis for creating rollover effects in ImageReady (see chapter 5). The Slice tool works much like the Rectangular Marquee selection tool; you just drag over the area you want to define as a slice. As you apply the tool, Photoshop automatically adds auto-slices in areas where you haven't used it. Use the Slice Select, too, to select slices you've already created. We'll discuss slicing in greater detail in chapter 5.

MOVE TOOL Use this tool to move or copy a selected area or vector object from one part of the canvas to another. If nothing is selected, the tool moves the entire layer.

LEFT **Crop tool.**

CENTER **Slice tools.**

RIGHT **Move tool.**

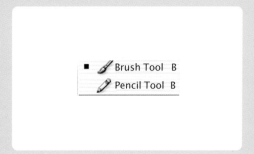

Painting Tools

Photoshop's painting capabilities received a major facelift with version 7 (see Creating Brushes, page 43). Using the Brushes palette, you can set up a wide range of brush styles with unique shapes, textures, edge effects, and color dynamics, then save them as presets that appear in the Options bar whenever you select a brush tool. You can also apply brush styles. Photoshop 7 also adds new blending modes, which determine how the brush interacts with the canvas, and two new painting tools, the Healing Brush and the Patch tool, both of which are especially useful for photo retouching.

Photoshop's painting tools are especially powerful when used in conjunction with a pressure-sensitive graphics tablet, such as Wacom's Intuos series. These tablets include pens with pressure- and tilt-sensitive tips that simulate real-world media. Using the Control options in the new Brushes palette (see page 43), you can set up tools in which the painting effect varies depending on how you tilt or press the pen.

BRUSH/PENCIL The Brush and the Pencil—both found in the same location in the Toolbox—are Photoshop's basic painting instruments. You use the Brush tool to paint soft strokes and the Pencil tool to paint with a harder edge. The Airbrush—previously a separate tool—is now an option for the Brush tool. Simulating a real-life airbrush, it applies the paint as gradual tones that build up as you hold down the mouse button or press with a stylus on a graphics tablet.

Through the Options bar, you can choose the brush size, brush shape, paint opacity, and flow, the latter determining the paint's density on the canvas. You can also choose from a variety of blend modes (see Blend Modes page 66). If the blend mode is set to Normal, the paint is simply laid on the canvas. But you can also choose other blend modes that cause the paint to interact with the canvas in different ways. For example, if you set the mode to Color, the brush colors the underlying area while preserving its luminosity—that is, the contrast between light and dark shades.

Creating Brushes

One of the biggest additions to Photoshop 7 is its enhanced painting engine, which you access through the new Brushes palette. Here, you can define a wide range of brush characteristics, then save them as presets that appear in the Presets palette or in the Options bar when you choose a painting tool.

Brush settings are divided into seven main categories: Brush Tip Shape, Shape Dynamics, Scattering, Texture, Dual Brush, Color Dynamics, and Other Dynamics. Beyond these categories, you can also use check boxes to add noise, wet edges, airbrush behavior, and smoothing, and you can set up brushes to preserve the underlying texture of the canvas. However, not all settings are available with every painting tool. For example, if you choose the Pencil tool, you cannot add wet edges or airbrush effects. If you choose the Art History Brush, you won't be able to define Scattering or Dual Brush characteristics.

To modify a category of brush characteristics, click on its name in the palette. As you modify the brush's characteristics, you'll see the results in the window at the bottom of the palette. To activate those characteristics for a particular brush, click in the checkbox next to the name.

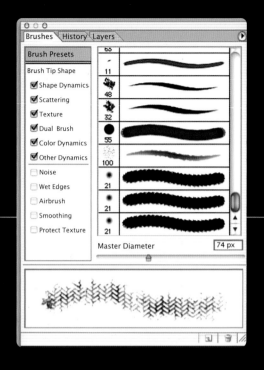

Many settings in the panels include Control menus that let you determine the behavior of a pressure-sensitive stylus. If a Control menu is available for a particular setting, you can use the pressure or the tilt of the stylus to vary the effect. For example, in the Shape Dynamics panel, you can use stylus pressure to vary the brush width and stylus tilt to vary the angle, making the tool act much like a real-life painting implement.

The best way to get to know the Brushes palette is to experiment with the settings and see what you come up with.

BRUSH TIP SHAPE Use these settings to define brush size, shape, roundness, angle, hardness, and spacing.

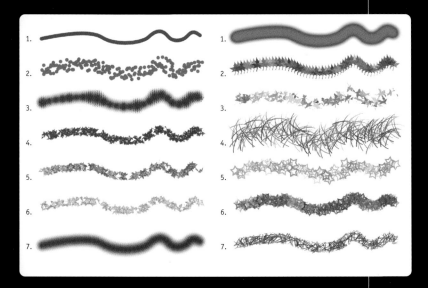

SHAPE DYNAMICS These settings allow you to add randomness to the brush's size and shape. For more randomness or variability, increase the jitter percentage.

SCATTERING These settings let you scatter the paint effect by specified amounts.

TEXTURE These settings add texture to the painting effect. A pop-up menu on top of the panel provides access to Photoshop's Pattern Picker, which includes built-in patterns along with any that you've created yourself. To produce a pattern for inclusion in the Pattern Picker, create one in a new file and choose the *Edit->Define Pattern* command.

DUAL BRUSH This feature lets you paint with two brush shapes simultaneously. The first brush shape is the one selected in the Brush Tip Shape panel. You choose the second brush shape here. Use the Mode pop-up to determine how the second brush interacts with the first.

COLOR DYNAMICS This feature lets you randomize the hue, saturation, and brightness in each brushstroke. Increase the jitter percentage for more randomness.

OTHER DYNAMICS Here you can randomize the opacity and flow of brush strokes.

Once you've defined the settings for a brush, use the Create New Brush command in the palette menu to save it as a preset. To open the palette menu, move the cursor to the arrow in the upper right corner of the palette and hold down the mouse button. As an alternative, you can click on the Create New Brush icon—the one resembling a folded piece of paper—on the bottom of the palette.

OPPOSITE PAGE LEFT **The Brushes palette provides extensive control over brush settings.**

OPPOSITE PAGE RIGHT **When you select a painting tool, you can choose from a long list of brush presets in the Options bar.**

ABOVE **Photoshop's new painting tools in action. On the left, from top: 1. Round brush stroke with no effects; 2. Scattering; 3. Texture; 4. Dual Brush; 5. Color Dynamics; 6. Other Dynamics; 7. Noise. On the right: 1. Wet Edges; 2. Leaf brush shape with color dynamics enabled; 3. Leaf shape with color dynamics, scattering, and dual brush enabled; 4. Blade shape with scattering and color dynamics enabled; 5. Star shape with color dynamics, other dynamics, and scattering enabled. 6. Star shape with texture, other dynamics and dual brush enabled; 7. Blade shape with texture and dual brush enabled.**

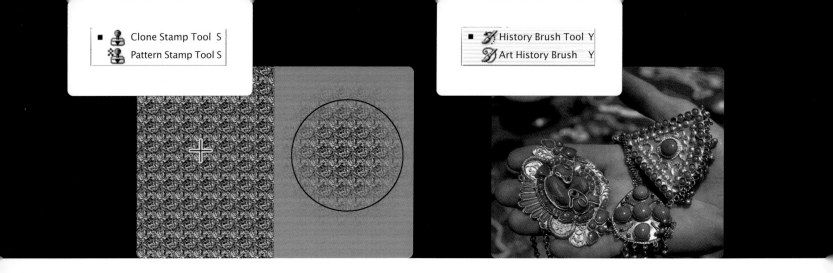

Clone Stamp Tool S
Pattern Stamp Tool S

History Brush Tool Y
Art History Brush Y

LEFT TOP The Clone Stamp and Pattern Stamp tools.

LEFT BOTTOM The Clone Stamp tool paints one part of an image into another. The area under the cross indicates the source, which is replicated in the destination area indicated by the circle.

RIGHT TOP The History Brush/Art History Brush tools.

RIGHT BOTTOM To show the History Brush in action, we began with this photo.

CLONE/PATTERN STAMP The Clone Stamp tool, useful for photo retouching, paints one part of an image into another. After selecting the tool, move it to the area of the image you want to replicate (the source), hold down the Option key, and click once. Then move to the area you want to paint (the destination). As you paint, the area where you Option-clicked is replicated in the area where you're painting. We'll discuss this tool in greater detail in chapter 3. The Pattern Stamp tool replicates a pattern in the area you're painting. You can use Photoshop's built-in patterns or create your own using the *Edit->Define Pattern* command.

HISTORY/ART HISTORY The History Brush lets you paint a previous version of the image into the current one. Think of it as an Undo brush, letting you restore parts of an image that have been modified.

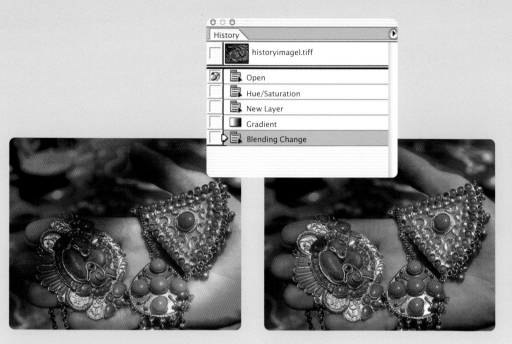

It works in combination with the History palette, which functions as a kind of time machine for work you've done in Photoshop. Each action you perform is recorded as a state that's displayed in the palette. You set the number of states the palette can remember in the Photoshop's General Preferences dialog box (*Photoshop->Preferences->General*). If you find that you've made a series of goofs, you can restore the image to any state listed in the palette. You can also take periodic snapshots of the image and store those as history states. In addition to using the palette, you can step forward or backward through history states using the Edit->Step Forward and Edit->Step Backward commands.

To use the History Brush, click next to a state in the History palette. This state becomes the source that's painted to the current version of the image.

The Art History Brush is useful for adding painterly effects to an image. As with the History Brush, you select a previous state of the image as the source. However, instead of painting directly from the source, it uses the source as a basis for stylized brushstrokes. You select the brush style in the Options bar.

LEFT **We applied layer-blending effects to add a rainbow color overlay to the image.**

CENTER TOP **We opened the History palette and chose the original image as the History Brush state.**

CENTER BOTTOM **We painted over the hand, restoring the original image in the painted area.**

RIGHT **The Art History Brush lets you recreate an image in painterly brushstrokes.**

LEFT Healing Brush/Patch tools.

CENTER Eraser tools.

RIGHT The Eraser removes everything in its path, making the layer transparent. If you erase on a background layer, the tool replaces the erased area with the background color displayed in the Toolbox.

HEALING BRUSH/PATCH These tools, new in Photoshop 7, allow you to remove scratches, compression artifacts, and other defects from an image. The Healing Brush works much like the Clone Stamp tool, allowing you to replicate pixels from a source in one part of an image to a destination in another. However, when you replicate the source, the brush automatically incorporates the destination area's colors, so the replicated pixels appear to blend in more naturally.

The Patch tool works like the Lasso tool, allowing you to use a selected part of an image as a patch to fix other parts. As with the Healing Brush, the patch automatically takes on the color characteristics of the patched area. We'll discuss these tools in greater detail in chapter 3.

ERASERS Photoshop provides three kinds of eraser tools: the basic Eraser, Background Eraser, and Magic Eraser.

The basic Eraser erases whatever is below it. If you're working on a background layer or a layer for which you've chosen the Lock Transparency option, it replaces the erased portion with the background color displayed in the Toolbox. Otherwise, the erased area becomes transparent.

The Background Eraser is useful for erasing skies and other backgrounds that contrast sharply with foreground objects. It works best when set to a large brush size. The tool appears as a circle that defines the area to be erased. In the middle is a small cross that samples the color underneath. Any color that closely matches the sampled color gets erased; colors that fall outside the tolerance range are left alone. Use the Tolerance setting in the Options bar to determine how closely the colors must match the sampled color to be erased. A low tolerance causes a smaller range of colors—only those that most closely match the sampled color—to be erased.

The Magic Eraser tool combines the features of the Background Eraser and the Magic Wand. Like the Background Eraser, it automatically erases colors that closely match a sampled color. However, you apply it like the Magic Wand, clicking once in the area you want to erase. The tool then removes all pixels that closely match the color you clicked on. As with the Background Eraser, use the Tolerance setting to determine the range of colors erased.

When you choose an eraser tool, you can use the Mode pop-up in the Options bar to have it behave as a brush, pencil, or block. It erases with a soft edge if you choose Brush and with a harder edge if you choose Pencil. The Block is Photoshop's version of the Model T—a square that comes in only one size.

LEFT **The Background Eraser removes all pixels within the brush area that closely match the color under the cross. You choose a tolerance percentage to determine how closely the colors have to match. Pixels that lie outside the tolerance range are not affected.**

RIGHT **The Magic Eraser removes all contiguous pixels that closely match the color where you clicked.**

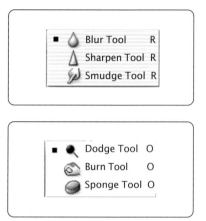

LEFT Gradient/Paint Bucket
tools.

CENTER You can select from
a variety of preset gradients
or create your own.

RIGHT TOP Blur/Sharpen/
Smudge tools.

RIGHT BOTTOM Dodge/Burn/
Sponge tools.

GRADIENT/PAINT BUCKET The Gradient tool paints a
gradient into a Photoshop layer, replacing the image
already on the layer. You can choose from multiple gra-
dient styles and color schemes in the Options bar. You
can also create a gradient layer using the *Layer->Create
Fill Layer->Gradient* command. The Paint Bucket tool
fills the selected area—or a solid color—with the
foreground color displayed in the Toolbox.

BLUR/SHARPEN/SMUDGE These tools don't add anything
to the image; rather, they modify the pixels already
present. The Blur tool blurs the area where you paint,
and the Sharpen tool sharpens it. The Smudge tool
shifts the pixels around as if you're finger painting.
Appropriately enough, the tool's icon is a finger
pointing down.

DODGE/BURN/SPONGE These tone tools allow you to
selectively modify the tone or saturation in an image.
The Dodge tool lightens the area where you paint,
while the Burn tool darkens it. The Sponge tool
saturates or desaturates the painted area depending
on which option you've chosen in the Options bar.
Saturation makes colors appear more vivid; desaturation
makes them grayer.

Working with Colors

Photoshop offers extensive features for choosing and working with colors. For example, you can select the foreground or background colors through the Toolbox, Eyedropper tool, painting tools, Swatches palette, or Colors palette. You can work in standard RGB or CMYK color modes or alternative modes such as Lab or Indexed Color. You select the mode to work in using the *Image-> Mode command*.

If you're creating graphics for deployment on the Web, you'll be working primarily in RGB, though you may have occasion to use the Indexed Color mode as well. In Indexed Color mode, you can limit the total range of colors to a specified number less than 256. For example, you can confine the colors to the 216 available in the Web-safe color palette. One downside of Indexed Color mode is that many image-editing operations are not available because they require a wider range of colors. You should never use Indexed Color mode when working with photos, which generally require millions of colors—or at least thousands—to look realistic.

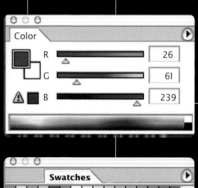

LEFT **Use the Colors palette (top) or the Swatches palette (bottom) to choose foreground or background colors. The Swatches palette is shown in Small Thumbnail view.**

The aforementioned Web-safe palette consists of
216 solid colors that can be shown on any Mac- or
Windows-compatible display, even those limited to
a total of 256 colors. Each color is identified in an
HTML document by a unique hexadecimal value—a
combination of six letters and numbers. For example,
pure RGB blue has a hexadecimal value of 0000FF,
while red has a value of FF0000.

#FFFFFF	#66FFFF
#FFFFCC	#66FFCC
#FFFF99	#66FF99
#FFFF66	#66FF66
#FFFF33	#66FF33
#FFFF00	#66FF00
#FFCCFF	#66CCFF
#FFCCCC	#66CCCC
#FFCC99	#66CC99
#FFCC66	#66CC66
#FFCC33	#66CC33
#FFCC00	#66CC00
#FF99FF	#6699FF
#FF99CC	#6699CC
#FF9999	#669999
#FF9966	#669966
#FF9933	#669933
#FF9900	#669900
#FF66FF	#6666FF
#FF66CC	#6666CC
#FF6699	#666699
#FF6666	#666666
#FF6633	#666633
#FF6600	#666600
#FF33FF	#6633FF
#FF33CC	#6633CC
#FF3399	#663399
#FF3366	#663366

a can use the
view in the
palette to list all
colors with their
al values.

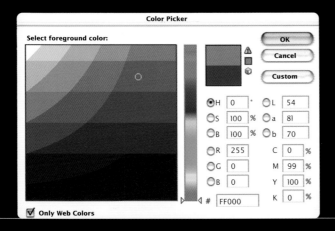

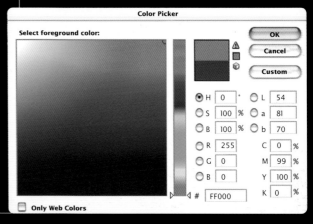

Photoshop provides two palettes for selecting colors Swatches and Color. By default, Swatches displays available colors in a grid format known as the Small Thumbnail view, or you can choose the Small List format in the palette's menu to display each color on a separate line. Color lets you build foreground or background colors by using slider controls to mix different percentages of RGB, CMYK, and other color components. Both offer the option of restricting colors to the Web-safe palette through commands in their respective palette menus.

You can also choose colors using Photoshop's Color Picker. To access this feature, double-click on the foreground or background color icons in the Toolbox or Color palette. Here again, you have the option of limiting the colors to the Web-safe palette. To do so, just click in the Web Colors checkbox on the bottom of the panel.

ABOVE **You can set up Photoshop's Color Picker to show only Web-safe colors (left), or any color that can be specified in RGB values, or values for other color spaces such as Lab (right).**

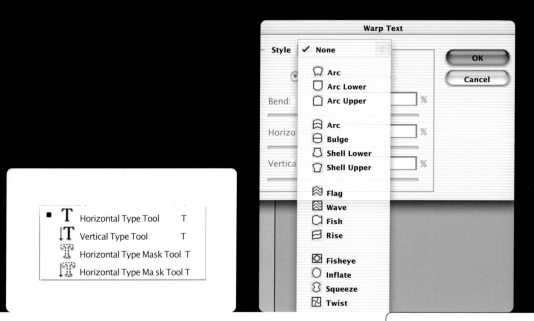

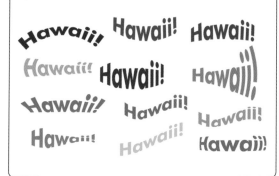

LEFT **Type tools.**

RIGHT **You can apply enve-
lope distortions to type
using the Warp Effects
option in the Option bar.**

Type

Photoshop's Type tools allow you to add text directly
on the canvas. When you select the tool and click on
the image, Photoshop automatically creates a new text
layer. The text remains editable as long as you don't
convert the layer to Vector-graphics or a raster format.
The Options bar provides basic text-formatting options,
including typeface, type size, alignment, color, and
antialiasing options. When one of the antialiasing
options is selected, Photoshop automatically smoothes
the edges of the text so it blends into the background.
If you're producing Web graphics, it's almost always
advisable to use anti-aliasing.

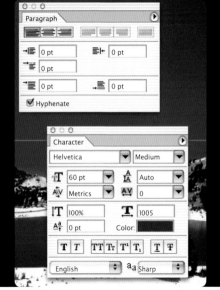

Photoshop's warped text options, also available through the Options bar, let you distort the text into a variety of shapes. In chapter 6, we'll show how you can animate the warp effects in ImageReady.

The Character and Paragraph palettes let you choose formatting options not available in the Options bar, including leading, tracking, kerning, and horizontal and vertical scaling. You can also define superscripts and subscripts.

In addition to the basic Horizontal Type tool, you can use the Vertical Type tool to enter text in a vertical column. The Horizontal and Vertical Type Mask tools provide a quick way to create masks out of text. As you type, the characters appear as selections rather than solid text.

ABOVE **The Character and Paragraph palettes provide enhanced control over type formatting.**

Vector Tools

Although Photoshop is primarily geared toward working with bit-mapped images, it includes several tools for creating and modifying vector graphics, which are also referred to as *paths* or *shapes*. They are especially useful for creating graphics with straight lines and smooth, evenly rounded curves. And unlike bitmaps, paths can be resized and reshaped to your heart's content without displaying jagged edges or other artifacts.

Photoshop's vector tools are simplified versions of the Bezier drawing tools found in Adobe Illustrator and Macromedia FreeHand. If you're familiar with one of those programs, you should be able to easily master Photoshop's vector tools. For the uninitiated, these tools allow you to precisely determine the size and shape of a curve by dragging on anchor points and control handles. You can also apply transformation options, such as Scale, Skew, Distort, and Perspective, through Photoshop's *Edit->Transform* submenu.

Paths serve multiple functions in Photoshop. You can use them to build with precisely defined lines and curves. You can create clipping paths that define the boundary of a layer. You also can transform them into rasterized images by applying fills to interior areas and strokes to borders; to do this, choose the Stroke Path or Fill Path commands in the Path palette menu. This capability is especially useful with the new painting functions in Photoshop. You can define a highly stylized brush style in the Brushes palette, then apply it to a path using the Stroke Path command. That's how we created the brush strokes on page 46.

PATH SELECTION/DIRECT SELECTION TOOLS The Path tool lets you select a path in the image. To do so, click once anywhere on the path. Once a path is selected, it can be resized, rotated, and distorted using the transformation commands in the Edit menu. The Direct Selection tool lets you select and modify points on the path.

PATH-CREATION TOOLS These tools let you create paths, add or delete anchor points, and convert straight lines to curves and vice versa.

The Pen tool, similar to the pen tools in Illustrator and FreeHand, lets you create lines or curves one point at a time. First, you click at the point where you want the line or curve to begin. This becomes your first anchor point. Then click where you want the line to end—the second anchor point. Continue adding anchor points if you want to create an object with multiple segments. The Freeform Pen lets you draw the path, automatically inserting anchor points as you draw. Use the Add or Delete Anchor Point tools to add or remove points from existing paths. Use the Convert Point tool to convert line segments to curves and vice versa.

LEFT **Path/Direct Selection tools.**

RIGHT **Path-creation tools.**

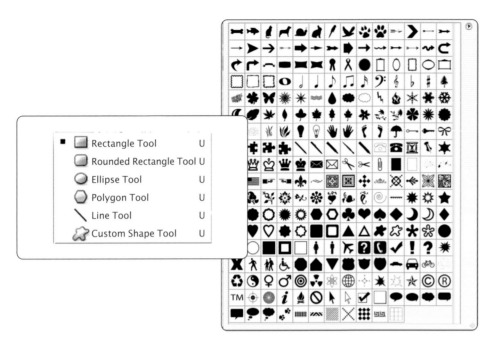

SHAPE TOOLS These tools provide a quick way to create common shapes: Rectangle, Rounded Rectangle, Ellipse, Polygon, and Line. Additionally, you can use the Custom Shape tool to choose more complex shapes from the Custom Shape Picker that appears in the Options bar.

Buttons on the left side of the Options bar let you choose how the shapes are created. The first, Shape Layer, adds a new, color-filled layer, with its boundaries defined by the shape you choose. The middle button, Create New Work Path, adds a new path that's displayed as Work Path in the Paths palette. Use this option if you want to employ the shape as a selection or clipping path, or if you want to later convert the shape to a raster format. The third button renders the shape as a bitmap instead of a vector graphic.

Notes/Audio Annotation

These tools let you append comments to the image you're creating. The Notes tool adds what's essentially an electronic sticky note in which you can type a message. The Audio Annotation tool lets you add an audio message, provided that you've connected a microphone to your computer.

LEFT **Shape tools.**

CENTER **The Custom Shape Picker lets you choose from a multitude of built-in shapes.**

RIGHT **Notes/Audio Annotation tools.**

Eyedropper/Color Sampler/Measure Tools

The Eyedropper tool lets you choose a new foreground or background color by clicking on a color in the image or in the Swatches palette. To select a foreground color, simply click. To select a background color, click while holding down the Option key. You can also call up the Eyedropper by holding down the Option key (Alt key in Windows) after you've selected a painting tool. In most cases, you'll find this to be a more efficient way to select colors.

The Color Sampler lets you place markers in an image that display the RGB (or CMYK) values of the underlying colors. Photoshop displays the color values for the markers in the Info palette. Each marker is identified by a unique number.

The Measure tool works like a digital tape measure, allowing you to determine the distance between different objects in the image. The measurements appear in the Info palette.

Hand Tool

This tool lets you view different portions of an image if it's too big to fit in the main window. Use it as an alternative to the scroll bars to drag the image in any desired direction.

Zoom Tool

This tool, with its magnifying glass icon, lets you zoom in and out of the image. You can zoom to any magnification level up to 1600 percent. You can also set zooming by choosing the *View->Zoom In* and *View->Zoom Out* commands or by entering a zoom percentage in the lower-left corner of the canvas.

LEFT **Eyedropper/Color Sampler/Measure tools.**

CENTER **Hand tool.**

RIGHT **Zoom tool.**

Color Management

One thorny issue for many Photoshop users is color management. This can be a problem on e-commerce sites, where people often return purchased items because the colors of the products they bought didn't match what they saw on screen.

Color-management software, such as Apple's ColorSync, is designed to ensure consistent reproduction of color across different monitors, printers, and printing presses. It does this, in part, through the use of profiles, compact files that define the color-reproduction characteristics of different output devices. In theory, a color-management system allows your computer to display the image as it will appear on other users' monitors. Photoshop provides extensive support for color management, including the ability to embed a color profile into an image.

But there are caveats:

- Your own monitor should be properly calibrated and have its own profile. Apple includes a display-calibration utility as part of the Monitors control panel in Mac OS 9 and System Preferences (Displays) in Mac OS X.

- Macintosh displays, by default, are slightly brighter than Windows displays. Their gamma—a measure of monitor brightness—is 1.8 compared with a standard PC's 2.2; the higher the gamma, the darker the picture. This presents a challenge for the many Mac-based designers who create pages viewed predominantly by Windows users. However, Apple's display calibrator lets you change the gamma to the PC-standard 1.8.

- For the color-management system to work, each Web user must have a well-calibrated display, and each must have a Web browser, such as Internet Explorer, that supports color management. If that's the case, the browser can use the embedded profile to automatically color-correct the image for reasonably accurate display.

Even if all conditions are met, color management is an inexact science, and it's impossible to guarantee absolute color fidelity on every display. Beyond the differences between Macs and PCs, CRT and LCD monitors display color differently, and the viewer's perception of color can depend on such uncontrollable factors as their ambient light in addition to idiosyncrasies of their computer systems.

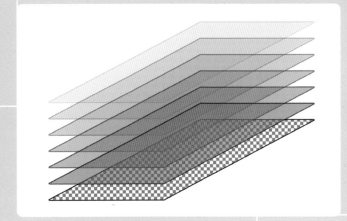

5 WORKING WITH LAYERS

A layer in a Photoshop file functions like a piece of painted glass. You can erase the paint to see layers below or make the paint semitransparent using opacity controls. You can also apply a cookie cutter to the glass in the form of a clipping path or layer mask, again revealing parts of the underlying layers. If all of the layers in the file are transparent, you'll see straight through to a checkerboard pattern known as the transparency grid.

You display and manage layers using the Layers palette and Layer menu. In addition, you can use the Styles palette to apply preset combinations of layer styles, such as drop shadows, beveled edges, and color overlays, to a selected layer.

ABOVE **Layers operate like sheets of glass or acetate, allowing you to build one effect or element on top of another. Below the layers lies the transparency grid.**

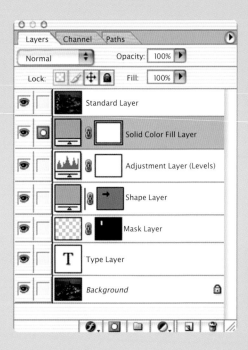

ABOVE This Layers palette shows the wide variety of layers you can create in Photoshop. The Layer Visibility box—the eye icon to the left of each layer—determines whether or not the layer is visible. Use the controls on top to select a blend mode or transparency options. You can also check the Lock boxes to lock in the layer's transparency, position, and other attributes.

A Photoshop file can include any of several types of layers:

BITMAPPED LAYERS These layers, by default, are transparent. If you erase part of the image on the layer, you'll see the layer below. You can also modify transparency using the Layer palette's opacity slider. However, if the Lock Transparency option is checked, you won't be able to modify the layer's transparency. If you erase part of a layer with locked transparency, you'll see the currently selected background color instead of the underlying layer.

BACKGROUND LAYER If you open an existing image in Photoshop, it automatically appears on what's known as a background layer. A background layer also appears if you create a new file with the Background Layer option selected. The background layer is like a standard bitmapped Photoshop layer, except it's locked: It's opaque, and you can't reposition or otherwise transform it (though you can transform selections on the layer)

and you can't move it above any other layers. You can convert a background layer to a standard layer using the *Layer->New->Layer from Background* command. You can also convert a standard layer to a background layer using the *Layer->New->Background from Layer* command. As you might expect, there can be only one background layer in a Photoshop file.

TYPE LAYER You create a new type layer whenever you select the Type tool and then click on the canvas. Any text you enter floats above the underlying layers. As long as it remains a type layer, you can go back and edit the text at any time. You can convert a type layer to a bitmapped layer using the *Layer->Rasterize->Text* command. However, once you do this, the text is locked into the bitmapped format and cannot be edited as text, although you can perform image-editing operations on it.

FILL LAYERS These layers are automatically filled with a solid color, gradient, or pattern. To create a fill layer, choose one of the three *Layer->New Fill Layer* commands: Solid Color, Gradient, or Pattern. You can modify an existing fill layer using commands in the *Layer->Change Layer* Content submenu.

SHAPE LAYERS These are layers with boundaries defined by clipping paths. The easiest way to create a shape layer is by using one of the shape tools in the Toolbox. When you select the tool, make sure the Shape Layer option is selected in the Options bar. Shape layers provide the best way to create buttons and other Web design elements. They are described in greater detail in chapter 4.

MASK LAYERS These are similar to shape layers, except their boundaries are defined by layer masks—that is, masks created with painting tools—instead of clipping paths, which are created using Photoshop's vector functions. We'll cover these in greater detail in chapter 3.

ADJUSTMENT LAYERS These layers don't have any content of their own but perform a specified image-processing effect on the layers below. The beauty of adjustment layers is that their effects are nondestructive. Instead of altering the content of the underlying layers, they function more like filtered lenses, except the effects they produce can be much more dramatic. If you remove the adjustment layer, the underlying layers appear just as they did before. You can choose any of 11 adjustment layers using the *Layer->New Adjustment Layer* submenu: Levels, Curves, Color Balance, Brightness/Contrast, Hue/Saturation, Selective Color, Channel Mixer, Gradient Map, Invert, Threshold, and Posterize.

ABOVE **Choose *Layer->Layer Style* to apply drop shadows, beveled edges, and other effects to the currently selected layer.**

The Layers Palette

Experienced Photoshop users learn to pay close attention to the Layers palette. Layers are central to many of Photoshop's most powerful capabilities, and the Layers palette is key to using layers effectively. Most of Photoshop's functions, including painting and selection tools, layer transformations, image-retouching operations, and filter effects, apply only to the currently selected layer. And Photoshop often adds layers to a document seemingly at its own whim—though it actually does so in a way that ultimately enhances productivity. For example, when you cut or paste a selection, or apply a type or shape tool, Photoshop—at least by default—automatically adds a new layer. Often, when it seems the program isn't working properly, Photoshop isn't at fault—you've just selected the wrong layer.

The palette lists each layer in the document, beginning with the one on top. To choose a layer to work on, you click on its name in the palette. Click in the Layer Visibility box (the eye icon) to make a layer appear or disappear from the image. You can group multiple layers so that a transformation, such as scaling or repositioning, applies to all layers in the group.

To simplify the management of layers, Photoshop lets you combine them into layer sets, which appear as folders in the Layers palette. For example, you might want to group all type layers into a single layer set.

You can quickly change a layer's appearance by applying layer styles through the Styles palette or the *Layer->Layer Style* submenu. The former lets you choose from preset styles; the latter lets you build styles by defining different combinations of shadow, edge, and overlay effects. This is an effective way to create buttons, backgrounds, and other graphic elements for Web sites.

When you select a layer, you can modify its overall transparency, including layer effects, or its fill transparency, which applies only to the layer's content. The latter option is useful with layer styles because drop shadows and other layer effects retain their full opacity.

Layer Menu

You'll find other commands for managing layers in the Layers palette menu and the Layer menu. You can:

• Apply masks or clipping paths to clip the layer's boundary.

• Rasterize type or vector layers into bitmapped layers, though they can no longer be edited in their original formats.

• Selectively merge layers or flatten all layers into a single, bitmapped background layer. Again, if you do so, you lose a great deal of flexibility in modifying the content of the file.

In addition to simplifying the creation of buttons and other elements, layers provide a starting point for the creation of rollovers and animations in ImageReady, which we'll discuss in chapters 5 and 6.

6 BLEND MODES

When you add a layer or apply a painting tool in Photoshop, you have the option of modifying how it interacts with the underlying image through its blend mode. If you choose the default Normal mode, the layer or painting effect lies on top of the image. But you can choose other modes that blend the layer or effect in different ways.

For example, if you choose Darken, only those portions of the layer or paint that are darker than the underlying layers will appear. If you choose Color, the layer or paint colorizes the image while retaining the luminosity—lightness or darkness—of each underlying pixel. Conversely, if you choose Luminosity, the layer or paint effect alters the tonal characteristics of the underlying layer, but not its color. You can modify the strength of a blending mode's effect by reducing the layer's transparency.

Many of Photoshop's layer effects, as well as the new brush effects, use blend modes such as Screen and Multiply as defaults. You can always change the default effect by selecting a different blend mode from a pop-up menu.

The best way to understand blend modes is to experiment with them. Here, we applied them with varying degrees of transparency to the rainbow gradient on the top layer to create blends with the layer on the bottom.

Blend Modes

1. Dissolve
2. Multiply
3. Screen
4. Overlay
5. Soft Light
6. Hard Light
7. Color Dodge
8. Color Burn
9. Darken
10. Lighten
11. Difference
12. Exclusion
13. Hue
14. Luminosity
15. Color
16. Saturation

OTHER PALETTES

We've already discussed many of Photoshop's palettes. Here are some we haven't covered:

File Browser

This palette, a new feature in Photoshop 7, lets you quickly scroll through the images stored on your computer or digital camera media. The left side of the palette displays a hierarchical list of folders and files. When you click on a folder containing images, they are displayed as thumbnails on the right side of the screen. You can also call up a detailed view that lists information about the image, including date and time created, and file type. You can rank images by degree of interest and sort them according to rank. Double-clicking on the thumbnail opens the image in Photoshop. You can call up the browser by choosing either *File->Browse* or *Window->File Browser*.

Navigator

This palette is useful if you're working with large, magnified images—or a small display. It shows the entire image along with a rectangular outline displaying what's visible in the main window. You can quickly move to a different part of the image by dragging the outline. The slider control on the bottom of the palette lets you vary the zoom percentage in the main window.

Info

This palette displays the current position of the cursor as numeric coordinates, along with RGB and CMYK color values for the area immediately beneath the cursor. If you've made a selection in the image, it also shows the width and height of the selection outline.

Styles

This palette displays Photoshop's Layer Styles, which are described in detail in chapter 4.

CLOCKWISE FROM LEFT
File Browser palette.

Info palette.

Styles palette.

Navigator palette.

CLOCKWISE FROM LEFT
Actions palette.

Tool Presets.

Channels palette.

Paths palette.

Actions

The Actions palette provides a powerful way to automate Photoshop operations. When you create an Action, Photoshop automatically records all operations you've performed on an image. You can then play back these Actions, either on the same image or new ones. The program includes a set of Default Actions that perform such functions as adding a wooden frame or a feathered edge to the image. Using the *File->Automate->Batch* command, you can apply an action you've created to a folder full of images.

Tool Presets

This palette, new in Photoshop 7, provides an alternative means of selecting paint and vector tools. You can store any combination of tools and brush presets, and sort them in various ways. Unlike the presets in the Options bar, which appear only when you click on a pop-up menu, tools in this palette are always available.

Channels

This palette lets you control the display and editing of individual channels in an image. These can be color channels, such as RGB or CMYK, or alpha channels storing image masks. We'll discuss channels in greater detail in chapter 3.

Paths

This palette lets you manage the paths in the Photoshop file. In addition to listing the paths in the image, it lets you convert them into clipping paths, selections, or bitmaps.

< Working with Photos >

For all its flexibility as a general-purpose graphics tool, Photoshop remains at its core a photo-editing program. Whether you want to fix a bad-looking photo or transform an ordinary one into a special-effects spectacular, Photoshop offers a range of powerful features for modifying and combining images. Poorly exposed photos that once would have died in a traditional darkroom can get a new chance at life and, thanks to the program's compositing features, you can create synthetic imagery that appears to be real—or surreal. Placed on the Web, images might lose some of the detail they have in print, but the Web also creates possibilities, such as animation, that aren't possible on a static page.

In this chapter, we'll cover the basics of Photoshop's photo-manipulation functions, beginning with retouching features designed to improve tonal balance, color accuracy, and sharpness. Then we'll move on to Photoshop's layering and masking features, which are key to its compositing and special effects capabilities. But first we'll discuss the nuts and bolts of obtaining images for use on the Web.

1 CAPTURING PHOTOS

Advancing technology has made it easier and less
costly than ever to capture high-quality digital
photos. Digital cameras let you shoot scenes and
store them directly as digital images. If your
images are prints or transparencies, you can use a
desktop scanner to convert the photos to a digital
format. If you don't trust your skills as a photog-
rapher (and don't want to hire one), you can also
try sampling the millions of stock photos available
on CD-ROM or through online media.

Digital Cameras

Digital cameras cover a broad range of price and capability, from $200 point-and-shoot models aimed at consumers to $50,000 camera backs designed for use with large-format cameras in photo studios.

The most important consideration in a digital camera is resolution, which is generally measured in megapixels. A 1-megapixel camera produces images with a total of at least one million pixels, with the common maximum resolution being 1280 by 960 pixels. Today, 2-, 3-, and 4-megapixel models are common.

At first glance, even a 1-megapixel camera would appear to be overkill for the Web, where images rarely measure more than 640 by 480 pixels. But there are many situations where the additional pixels come in handy. You gain extra flexibility in cropping and scaling, and some operations, such as compositing, are best performed on large-sized images, which can then be reduced to a format more appropriate for the Web. If images are destined for print as well as online, then you'll likely need a 3- or 4-megapixel model.

Megapixels alone do not a digital camera make. A camera's optics and internal processing software also play an important role in image quality, which is why it's important to check out the reviews in photo or computer magazines. Other features to look for include optical zoom (as opposed to digital zoom, which is nearly worthless) and the camera's flash features—most have internal flashes, but higher-end models connect to external flash units as well.

Storage capabilities also vary; most cameras store images in one of several removable flash memory media formats, such as SmartMedia, CompactFlash, or Sony's Memory Sticks. These formats store data on a computer chip encased in a small, removable card. Most cameras can transfer images to the computer through the popular Universal Serial Bus (USB) interface, but some users prefer card readers, devices resembling floppy drives that read data from the removable media. Card readers also connect through USB, and most support multiple formats. They generally sell for less than $100.

Scanners

Unlike digital cameras, scanners measure resolution in dots per inch (dpi). Inexpensive flatbed scanners typically range from 300 to 1200 dpi, while costlier flatbed and drum models designed to capture slides and transparencies range up to 5000 dpi. In most cases, you'll get a better-looking image from a transparency than from a print.

Although designed to capture continuous-tone images, such as photographs, some models include descreening functions that enable scanning of halftone images in books or magazines. The scanning software transforms the halftone dots into continuous shades so the image can be printed without a moiré pattern. Many scanning programs can also perform automatic image-correction functions as the photo is being scanned. Most scanners sold today connect to the computer through a USB or FireWire interface; older models used the SCSI interface.

The pixel resolution of a scanned image depends on two factors: the total size of the image and the dpi setting. For example, a photo measuring 4 by 3 inches will measure 400 by 300 pixels when scanned at 100 dpi and 600 by 450 pixels when scanned at 150 dpi. If you know the final dimensions you want, you'll have a good idea of what resolution to use. However, it's often smart to begin with a bigger image than you'll ultimately need for the same reasons you may want to capture megapixel images with a digital camera: for cropping and scaling, and to enable detailed compositing or retouching work.

Given Photoshop's photo-manipulation capabilities, it is tempting to say that the old computer concept of garbage in, garbage out no longer applies. However, while it is true that Photoshop can rescue many lousy-looking images, you're still better off getting it right from the beginning—when you snap the picture. Most tonal and color adjustments, which generally make a picture look better, also have side effects. They work best when applied in moderation. The closer you get to perfection in the original, the less you'll have to do in Photoshop.

LEFT **Scanners, such as this flatbed model from Agfa, transform photographic prints and transparencies into digital formats.**

2 PHOTO-RETOUCHING TECHNIQUES

Entire books could be written about Photoshop's photo-retouching capabilities and, indeed, several volumes have been published on the subject. Such a comprehensive guide to retouching is beyond the scope of this book, but here we'll look at some common problems seen in photographs and offer basic techniques for correcting them.

Adobe suggests a six-step process for correcting images:

1. Calibrate your monitor.

2. Check the image quality and tonal range. Tonal range refers to the distribution of highlights, shadows, and midtones in an image.

3. Adjust the tonal range.

4. Adjust the color balance.

5. Make other special color adjustments.

6. Sharpen the edges of the image.

You don't necessarily have to perform each step on every image you encounter. For example, after you adjust tonal range, you might find that the color balance is fine. But you'll likely get the best results if you follow the steps in the specified order.

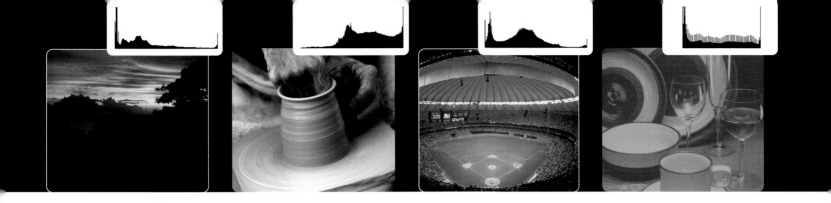

Now let's examine each aspect of photo retouching up close.

Tonal Range

A good-looking image should generally have a broad range of tonal values from light to dark, with sufficient detail in highlight, shadow, and midtone areas. The best way to check this is through a histogram, a graph that displays tonal information in the form of vertical lines. Each line represents a specific tone or intensity value ranging from pure black on the left to pure white on the right. Numerically, black is assigned a value of zero and white a value of 255, with other tones falling in between for a total of 256 possible values. (Note that we're talking about tones, not colors. For now, we're concerned about the luminosity or intensity of pixels in an image, not their color.)

The length of the vertical line indicates the number of pixels with the same tone; the longer the line, the greater the number of pixels holding that tonal value. In a dark image, you'll see longer lines toward the left side of the histogram. In a lighter image, longer lines will be shifted toward the right. In an image where midtones dominate, the histogram will look somewhat like a bell curve, with the longer lines toward the center. If an image has a limited tonal range, you'll see gaps on the left and/or right, meaning that the darkest shade in the image is less than black or that the lightest shade is less than white. In visual terms, the image will appear to be washed out and lacking in detail.

FROM LEFT TO RIGHT
A histogram displays tonal information as a series of vertical lines. In an image with heavy shadows, the longer lines appear toward the left, indicating that most of the pixels are dark.

In a lighter image, the lines shift to the right.

As the histogram shows, midtones dominate this image, though there's a spike on the left resulting from the large shadow areas around the border.

This image has a limited tonal range and thus appears to be washed out.

LEFT **Photoshop's Levels function incorporates a histogram along with controls for modifying the tonal range.**

LEFT BOTTOM **Photoshop 7 adds a new Histogram function.**

RIGHT **We reset the white and black points using the slider controls. Now the image has a much broader tonal range.**

Photoshop 6 and 7 both display a histogram as part of the Levels function, which also provides a relatively easy way to adjust tonal range. Additionally, Photoshop 7 includes a separate Histogram display function (*Image->Histogram*) if you merely want to inspect the tonal quality of the image.

In the Levels dialog box, you'll see three slider controls just below the histogram. The first slider sets the black point; you can also enter the numeric value for the black point in the first Input Levels field above the histogram. By default, it's all the way to the left (numeric value zero). Sliding it to the right increases the darkness of shadow areas. You set the white point using the third slider or by entering a numeric value in the third Input Levels field. By default, it's all the way to the right and has a numeric value of 255. Sliding it to the left increases lightness in highlight areas. If an image already has good tonal range—if the darkest point is black and the lightest point is white—you probably won't want to tinker with these controls, but if the image is washed out, as in the example above, you can improve the tonal range by resetting the white and black points.

The second slider determines the midpoint. All pixels to the right of the midpoint have a tonal value of 128 or more; all those to the left have a value of 127 or less. If you slide the control to the right, you darken the midtones, because a greater percentage of the pixels fall into the darker half of the tonal range. If you slide it to the left, you lighten the midtones. With many images, this provides a quick way to fix images that are over- or underexposed.

As with most of Photoshop's image-adjustment options, Levels can be applied directly to an image (*Image->Adjustments->Levels*) or as an Adjustment Layer (*Layer->New Adjustment Layer->Levels*). An Adjustment Layer, as you'll recall, is a special kind of layer that has no content of its own but rather applies a particular image-processing effect to the layers below it. One advantage of Adjustment Layers is that they don't actually change the underlying layers. Instead, they act more like a filtered lens on a camera. If you remove the Adjustment Layer or move the underlying layers

above the Adjustment Layer, the image returns to its former state. In contrast, if you apply Layers or other operations directly to the image, it is permanently changed, and you'll need to use Photoshop's Undo or History functions to restore it. Adjustment Layers also make it easier to experiment with different settings because you can change the values of a particular Adjustment Layer at any time by double-clicking on its thumbnail in the Layers palette.

Levels, along with most of Photoshop's other image-adjustment features, includes a Preview checkbox that shows the current effect applied to the image. If you want to visually assess the changes to the image, try clicking the Preview box on and off—it works like a toggle, showing the image with and without the effect. Once you've applied the effect, you can choose *Edit->Undo* and *Edit->Redo* to toggle between the Levels effect and the original unmodified image.

LEFT **The midtone slider lets you lighten or darken the midtones in an image while preserving detail in highlight and shadow areas.**

RIGHT **You can apply Levels and other retouching features as Adjustment Layers, which modify the appearance of the underlying layers without altering the actual content. You can change the settings at any time by double-clicking on the thumbnail for the adjustment effect.**

Emulating Windows

One challenge for many Web designers is getting accurate previews of how images will look on different computer platforms. The Macintosh, the favored computer of most designers, has a slightly brighter display than Windows PCs, so images that look fine on a Mac will look a little dark in Windows. In technical terms, the brightness of a display is referred to as its gamma. The Mac uses a default screen gamma of 1.8, while Windows PCs use a gamma of 2.2. A higher gamma means a darker picture.

The midtone control in the Levels dialog box provides a quick way to see how an image created on a Mac or PC will appear on the other platform. By lowering the setting a couple of notches, say from 1 to 0.8, a Mac designer can increase the gamma and get a rough idea of how an image will look on a Windows monitor. As we noted in chapter 2, you can also adjust your monitor's gamma through Apple's Display Calibration utility.

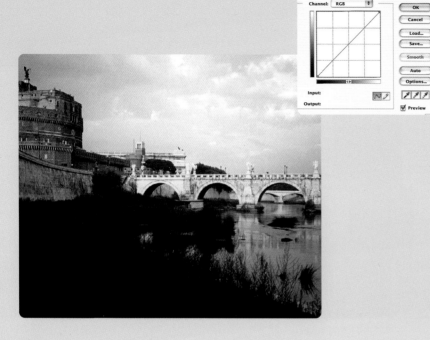

Curves

Photoshop's Curves function, while not quite as intuitive as Levels, provides greater control over tonal values. Here, the tones are represented in a simple line graph. The horizontal axis on the bottom represents the tones in the original image, with darkest tones on the left and lightest tones on the right. The vertical axis on the side represents the tones in the new, modified image, with darkest tones on the bottom and the lightest ones on top. By changing the shape of the line, you can remap the tones in the original image to lighter or darker tones in the modified version. For example, if you reverse the slope of the line so that it runs from upper left to lower right, the image becomes a negative because white pixels in the original are mapped to black pixels in the modified image and vice versa. But you can also use Curves for more subtle effects:

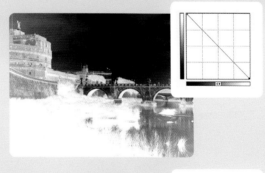

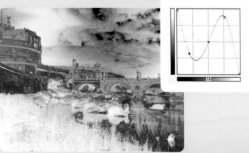

ABOVE **The Curves function displays tonal information in the form of a line graph. The horizontal axis represents tones in the original image, ranging from black on the left to white on the right. The vertical axis represents tones in the modified version of the image. The line shown here does not change the image because each tone in the original maps to the same tone in the modified image.**

LEFT TOP **When you reverse the slope of the line, Curves transforms the image into a negative; dark tones in the original are mapped to light tones in the new image and vice versa.**

LEFT BOTTOM **This curve creates a solarizing effect.**

FAR RIGHT **The Pencil tool permits unusual curve effects. This curve posterizes the image by limiting the number of tones.**

1. With an image open, choose I*mage->Adjustments->Curves* or *Layer->New Adjustment Layer->Curves*.

2. Click on the curvy line icon if it isn't selected already. Then click once in the center of the line. A control point should appear.

3. Move the mouse over the control point and, as you're holding down the mouse button, move it slightly toward the upper left. The line will change into a bow shape. If the Preview is checked, midtones will appear lighter because you've remapped the midtone values in the original to higher ones in the modified image. If you drag the control point toward the lower right, midtones will appear darker. Either way, tonal values in shadow and highlight areas are largely preserved.

4. Add new control points by clicking elsewhere on the line. Note that as you increase or decrease tonal values on one side of a control point, the curve on the other side of the point moves in the opposite direction. If this isn't the effect you want, use extra control points to straighten the curve. The result is a curve that brings out shadow detail in the image while having minimal impact on lighter areas.

As an alternative to control points, you can use the Pencil tool in the Curves dialog box to redraw the line freehand. The pencil lacks the click-and-drag simplicity of the default curve tool but enables effects that you can't otherwise create in the Curves dialog box, such as the posterization effect seen here.

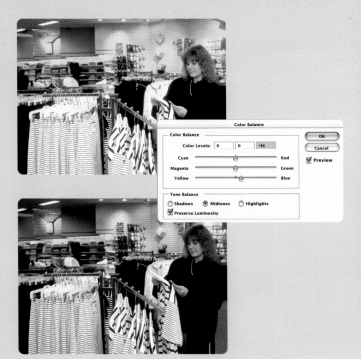

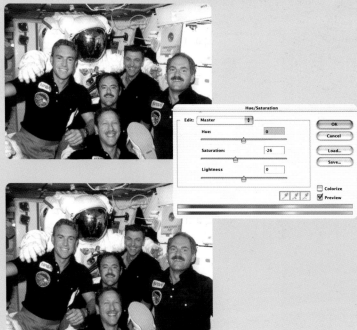

Correcting Color

Not surprisingly, Photoshop provides numerous tools for modifying colors in a photo. We'll look at two in particular: Color Balance and Hue/Saturation.

Color Balance (*Image->Adjustments->Color Balance*) is a good way to fix color cast, in which a certain color overwhelms all others in the image. For example, when shot under certain lighting conditions, an image might look too green or too red. Using the slider controls, you can selectively increase or decrease the percentage of red, green, and blue primary colors in the highlight, shadow, and midtone areas.

The Hue/Saturation control (*Image->Adjustments->Hue/Saturation* or *Layer->New Adjustment Layer->Hue/Saturation*) has numerous uses, but one common application is reducing or increasing saturation, which refers to the purity of a color. Increasing saturation makes colors look more vibrant. Decreasing it makes colors look grayer. In the example here, the image of the astronauts is oversaturated, so we move the Saturation slider to the left.

LEFT Color Balance lets you remove color cast by modifying the balance of primary colors. Here, we use it to remove a yellow cast. You can modify Color Balance separately for highlights, shadows, and midtones.

RIGHT The Hue/Saturation control makes these astronauts look a little less colorful.

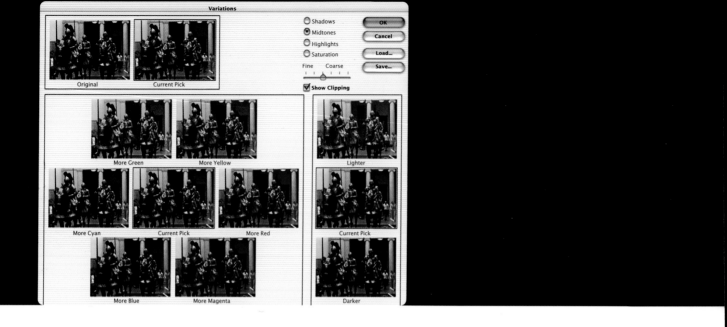

ABOVE **Variations lets you color-correct an image by choosing thumbnail versions that more closely match the color you want.**

If you don't want to fiddle with slider controls or numeric values, Photoshop's Variations feature provides a highly visual—but less precise—means of correcting color. Variations presents the original image along with six thumbnails showing added red, green, blue, cyan, magenta, and yellow. When you double-click on the thumbnail that looks best, that becomes the new image, and Variations presents a new set of thumbnails that you can use for further modifications.

To increase the amount of variation, move the slider control toward Coarse. Each notch doubles the amount of color added. Keep in mind that adding cyan, magenta, and yellow has the same effect as subtracting red, green, and blue respectively. For example, if you want to make the image less red, choose More Cyan. You can also use Variations to modify saturation and brightness.

If you expect to perform frequent color-correction operations, some third-party plug-ins can make the process easier while providing more control over the results. The best known of these programs is Vivid Details' Test Strip, which one reviewer has described as "variations on steroids." Another contender is Intellihance Pro from Extensis Products Group.

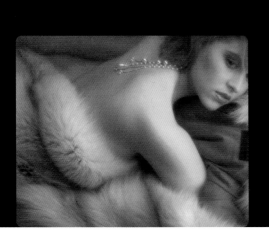
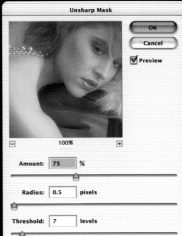
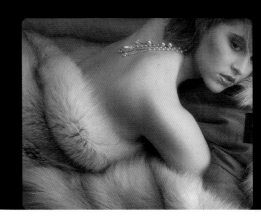

Sharpening

If an image appears to be too soft, you can sharpen it using a Photoshop filter that goes by the unlikely name of Unsharp Mask. Based on a traditional camera technique, the filter selectively increases the contrast between edge pixels—that is, pixels that are sufficiently different from those around them. It has three settings:

1. *Amount* determines the amount of contrast. For most Web images, try a value between 50 and 100 percent; for high-resolution images destined for print, try a value between 150 and 200 percent.

2. *Radius* determines the width of the sharpening effect. Lower values sharpen only the edge areas, while higher values sharpen a wider region. For online images, try a setting of 0.5 or 1.0. For high-resolution print images, try a setting between 1 and 2.

3. *Threshold* determines how many pixels will be regarded as edge pixels. Entering a higher value tells Photoshop to apply the filter in areas where there is a relatively big difference between the edge pixels and surrounding ones. The default value of zero sharpens all pixels. Try values between 2 and 20 to limit the effect.

LEFT, CENTER, RIGHT **The Unsharp Mask function, despite its confusing name, can be used to sharpen images with soft detail.**

Quick Photo Adjustments

Along with the retouching features discussed here, Photoshop also includes several features that let you make quick and dirty adjustments to the tone or color of an image. They don't offer the precision of the Levels, Curves, or Color Balance functions, but they do offer single-click simplicity. In some cases, you may want to try one of these automatic functions to see if the results are satisfactory. If they're not, you can always undo the effect and try the more elaborate retouching techniques described above. You can access these features through the Image->Adjustments submenu.

Auto Levels performs an automatic Levels adjustment; Auto Contrast automatically adjusts contrast; and Auto Color, a new feature in Photoshop 7, automatically modifies color balance. None of these features comes with any options; just choose the command and see what happens. If you don't like the results, you can undo the function and try one of the more precise image-correction features.

1.

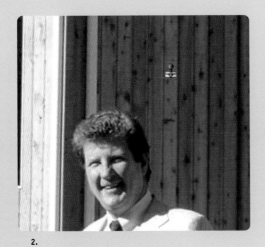
2.

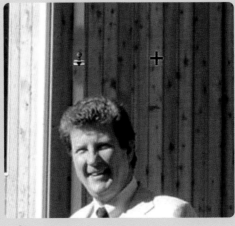
3.

Beyond Color and Tone

Sometimes fixing tone or color isn't enough; you actually have to change the content of the image. There might be objects in the original scene that detract from the composition, or noise or other distortions that somehow made their way into the image. A great way to remove these artifacts is to use Photoshop's Clone Stamp tool.

The Clone tool replicates one part of an image in another. You can thus use it to cover the unwanted artifacts with the patterns that surround them. In the example here, we used the tool to remove a drainpipe that appeared to be rising out of the realtor's head.

1. Select the Clone Tool and choose a brush size from the Options Bar. Soft brushes tend to work better than hard-edged ones. Be sure the Aligned option in the Options Bar is checked.

2. Move the mouse to the area you want to clone. In this example, we'll use the wood texture as the source to cover the drainpipe. As you hold down the Option key, click once with the mouse.

3. Move the mouse to the part of the image you want to paint over (the destination). Hold down the mouse button and begin painting. As you paint, a moving cross indicates the exact area that you are cloning from. Pay attention to the cross's position; if you move the brush too far in the wrong direction, you may end up cloning from areas you don't want to replicate.

LEFT **Here, we used the Clone Stamp tool to remove the drainpipe in the background.**

Healing and Patch

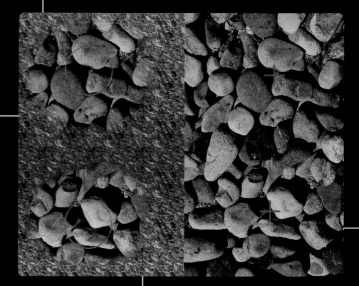

Photoshop 7 introduced two new tools, the Healing Brush and Patch tools, that provide another way to remove unwanted artifacts from photo images. The Healing Brush works much like the Clone Stamp tool, allowing you to replicate a source in one part of an image to a destination in another. But when it does so, it automatically incorporates the destination area's colors, so the replicated pixels appear to blend in more naturally.

The Patch tool works much like the Lasso selection tool. You can select an area of an image to use as a source, and then apply it as a patch by dragging it to a destination. When you apply the patch, it takes on the destination area's colors, as the Healing Brush does. This tool can be a little confusing, because the area you select can either be the patch that fixes something else in the image, or the part of the image that needs to be fixed. If you want to use the selection as a patch, click on Destination in the Options bar, and then drag the selection to the area you want to fix. If you want to patch the selected area, click on Source in the Options bar, and then drag the selection to the area you want to use as a patch.

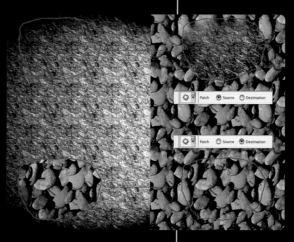

TOP **The Healing Brush and Patch tool.**

MIDDLE **Unlike the Clone Stamp (top), which replicates the source image in the destination area, the Healing Brush (bottom) applies the destination area's colors, so the source appears to blend in.**

BOTTOM **The Patch tool operates in two directions. If you choose Source (top), the area you select with the tool gets patched by the area you drag it to. If you choose Destination (bottom), the area you select with the tool becomes a patch to use elsewhere.**

3 CREATING SPECIAL EFFECTS

Photoshop's built-in filters provide myriad ways to quickly create special photographic effects. For example, using the artistic, brushstroke, and sketch filters, you can transform a photograph into an image that resembles a painting or drawing. These filters are sometimes referred to as "gallery effects" because many are derived from an old plug-in package of that name. However, caution is warranted here. Many of these filters—especially the gallery effects—have been around for ages and thus have attained the dubious status of artistic clichés. If you want your work to look original, you'll need to use the filters creatively.

After you apply a filter, you can moderate its effect by choosing the *Edit->Fade* command. This command also lets you change the filter's blend mode from Normal to something else, such as Color. The *Filter->Last* Filter command (Cmd-F) automatically applies the last filter you used to the current layer. Keep in mind that if you don't like the effects provided by Photoshop's built-in filters, you can also add third-party filter collections such as Procreate's KPT Effects and Alien Skin Software's Eye Candy.

In the pages that follow, we show examples of Photoshop's special-effects filters in action. Then we show how you can use the filters in combination with Photoshop's layer functions to create a more original look.

1. Original image

2. Colored Pencil

Artistic Filters

3. Cutout

4. Dry Brush

5. Film Grain

6. Fresco

7. Neon Glow

8. Paint Daubs

9. Palette Knife

10. Plastic Wrap

11. Poster Edges

12. Rough Pastels

13. Smudge Stick

14. Sponge

15. Underpainting

16. Watercolor

1.

2.

3.

4.

5.

6.

7.

8.

Distort Filters

1. Diffuse Glow
2. Displace
3. Glass
4. Ocean Ripple
5. Pinch
6. Polar Coordinates
7. Ripple
8. Shear
9. Spherize
10. Twirl
11. Wave
12. ZigZag

Noise Filters

13. Add Noise
14. Median

1.

2.

3.

4.

5.

6.

7.

8.

9.

10.

11.

12.

13.

14.

1.

2.

3.

Pixelate Filters

1. Color Halftone

2. Crystallize

3. Facet

4. Fragment

5. Mezzotint

6. Mosaic

7. Pointillize

4.

5.

6.

7.

1.

2.

3.

Render Filters

1. 3D Transform

2. Clouds

3. Difference Clouds

4. Lens Flare

5. Lighting Effects

4.

5.

Sketch Filters

1. Bas Relief

2. Chalk and Charcoal

3. Charcoal

4. Chrome

5. Conté Crayon

6. Graphic Pen

7. Halftone Pattern

8. Note Paper

9. Photocopy

10. Plaster

11. Reticulation

12. Stamp

13. Torn Edges

14. Water Paper

1.

2.

3.

4.

5.

6.

7.

8.

9.

10.

11.

12.

13.

14.

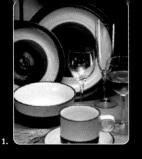 1.

 2.

 3.

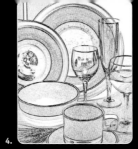 4.

Stylize Filters

1. **Diffuse**
2. **Emboss**
3. **Extrude**
4. **Find Edges**
5. **Glowing Edges**
6. **Solarize**
7. **Trace Contour**
8. **Wind**

 5.

 6.

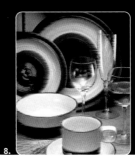 7.

 8.

 1.

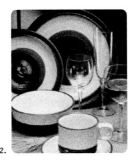 2.

 3.

Texture Filters

1. **Craquelure**
2. **Grain**
3. **Mosaic Tiles**
4. **Patchwork**
5. **Stained Glass**

 4.

 5.

4 USING FILTERS WITH LAYER BLENDS

One way to create special photographic effects in Photoshop is to use filters or image adjustments on individual layers within an image, then apply blend modes to the layers. That's what we did to create the effects you see here. We began with a photo of a fish and used the *Layer->Duplicate Layer* command to create a second layer containing an exact copy. Then we applied a filter and/or image adjustment to one or both of the layers and chose a blending mode for the layer on top. The first image you see is the bottom layer, the second the top layer. The third image shows the final result with the blending mode applied.

TOP ROW The blend mode for the top layer, shown on the left, is set to Luminosity. On the bottom layer (middle), we applied Hue/Saturation to shift the colors, along with several filters, including Median and Gaussian Blur. The result is shown on the right.

BOTTOM ROW On the top layer, we set the blend mode to Overlay and used *Image->Adjustments-> Brightness/Contrast* to crank up the contrast by 70 percent. We applied the Poster Edges filter to the bottom layer. This is a good way to make your photos look like illustrations from a comic book.

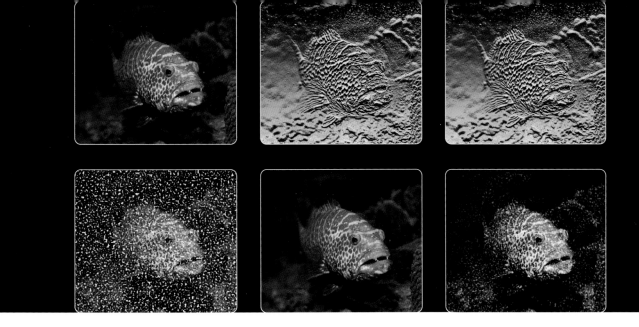

TOP ROW Here, we set the top layer's blend mode to Color and applied the Bas Relief filter to the bottom layer.

BOTTOM ROW To create this effect, we applied the Pointillize filter to the top layer and set its blend mode to Overlay. We didn't apply any filters or adjustments to the bottom layer.

RIGHT If the fish are around, a fisherman can't be far behind. This image consists of three layers. We used the Color Blend mode on the two layers to colorize a black-and-white photo of a fisherman on the third. The fourth image shows the results. In the next section, we show another way to colorize a black-and-white image.

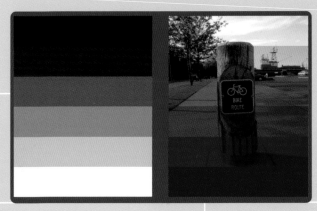

5 MASKING TOOLS UNMASKED FOR THE WEB

Photoshop's masking tools provide another powerful way to create special photographic effects. Masks can be thought of as digital stencils, allowing you to restrict painting and image-editing operations to precisely selected areas of a photo. Unlike paths, which also permit precise selections in an image, masks can be created using Photoshop's painting tools, which usually are easier to handle than path tools. Masks also allow gradient effects that aren't possible with paths.

One benefit of Photoshop's masking tools is its ability to create images with irregular shapes that seamlessly blend into the background of a Web page or banner ad. When a layer mask is applied, the masked portion of the layer becomes transparent and the background shows through. If you know the background color ahead of time, you can place a layer matching that color underneath the masked layer. Even if you don't know the background color, you can use the transparency options in Photoshop's Save for Web feature

to blend the masked layer into the background. However, if you choose the latter approach, you'll have to save the image in GIF format, instead of the more photographically friendly JPEG format, to take full advantage of transparency. We'll cover these formats, along with Save for Web, in chapter seven.

A mask is a gray-scale image that's stored in a special kind of channel known as an alpha channel. White areas represent the unmasked portion of the image, the part that will be affected by any editing operations you perform. Black areas represent the masked portion, which is shielded from those same operations. If the mask includes gray shades, then painting and image-editing effects (most of them) will be applied with variable intensity in the shaded areas.

LEFT **Masks let you isolate parts of an image to be modified.**

RIGHT **The intensity of the gray shade in the mask (left) determines how much red paint is applied to the image (right). The image is completely masked in the black areas and completely unmasked in the white areas.**

1.

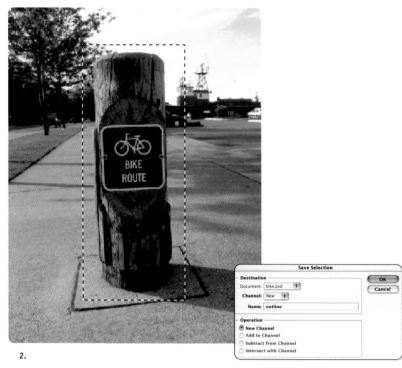

2.

Save Selection

Destination
Document: bike.psd
Channel: New
Name: outline

OK
Cancel

Operation
◉ New Channel
◯ Add to Channel
◯ Subtract from Channel
◯ Intersect with Channel

3.

Masks have numerous uses. In addition to allowing selective image effects, they provide the basis for Photoshop's compositing capabilities with which you insert part of one image into another. You can also use them to define the shapes of buttons and other elements, and then apply Layer Styles to create objects with depth and photorealism.

A single Photoshop file can include multiple masks, each isolating a different part of the image. You can also create layer masks, which hide the masked portion of the layer, letting you see the layers underneath. Layer masks, as we'll see later on, are useful for creating composites.

We'll begin by creating a relatively simple selection mask, then go on to show some more-elaborate masking effects.

Creating a selection mask

1. Open the file to which you want to apply a mask. We'll begin with a photo of a street sign.

2. Using the Marquee selection tool, draw a rectangle around the post. This will provide the rough beginnings of the mask.

3. Choose *Select->Save Selection*. We'll name the selection Outline. When you click OK, you've created a mask, which is now stored in a new alpha channel.

4. Choose *Window->Show Channels*. The new channel, "Outline," is listed at the bottom. Choose *Select->Deselect All* (Cmd-D) to remove the Marquee selection. You don't need it, because the shape is stored in the alpha channel, and it can now be loaded at any time.

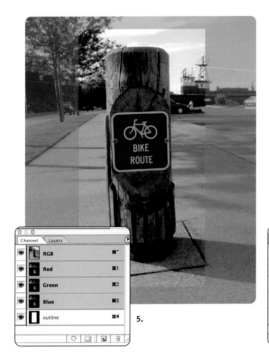

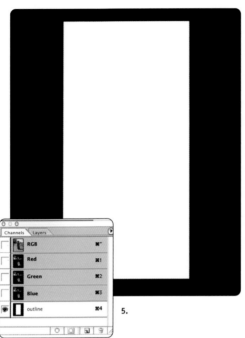

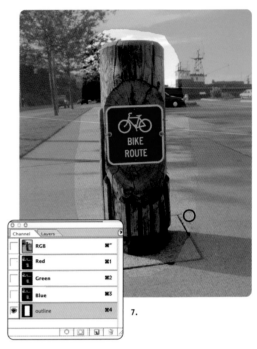

5. Click in the Channel Visibility box next to the Outline channel so you can see the contents of the channel (the eye icon indicates visibility). If the RGB channel is also visible, you'll see the mask as a red transparent overlay. If the RGB channel is hidden, you'll see the mask as a gray-scale image.

6. Click on the Outline channel to activate it. The name of the channel will be highlighted in blue. Painting operations will now apply to the Outline mask instead of the image itself.

7. Using the Pencil tool, paint in the portions of the image around the post. Zoom in and use smaller brush sizes for precise detail.

8. When the mask is finished, click on RGB to activate the RGB channel. Now painting operations will apply to the image instead of the mask.

9. Choose *Select->Load Selection*. Choose *Outline* from the list of masks, and check *Invert*. This will reverse the mask since we want to apply our imaging magic to the background, not the foreground object.

Load Selection

Source

Document: bike.psd

Channel: outline

☑ Invert

OK
Cancel

Operation

⦿ New Selection

◯ Add to Selection

◯ Subtract from Selection

◯ Intersect with Selection

9.

10. The image appears with the background selected.

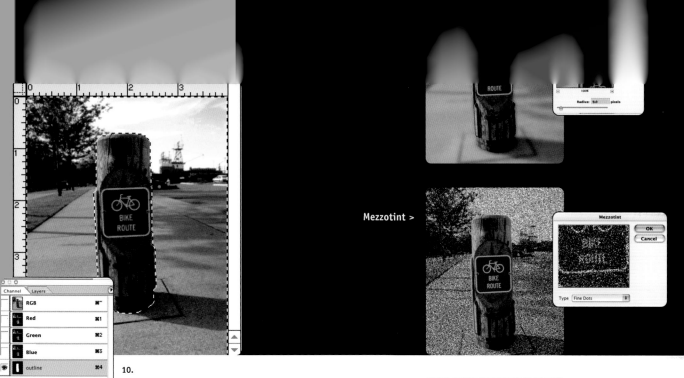

Mezzotint >

Hue/Saturation with >
Colorize option enabled

Torn Edges >

11. As a final step, we feather the selection (*Select->Feather*). This blends the pixels along the edges of the selection, creating a smoother outline.

Feather Selection

Feather Radius: 3 pixels

OK

Cancel

11.

With the mask in place, you can apply a wide range of image effects to the background, while the foreground remains unchanged: Gaussian Blur (*Filter->Blur->Gaussian Blur*); Mezzotint (*Filter->Pixelate->Mezzotint*); Hue/Saturation (*Image->Adjustments->Hue/Saturation*); and Torn Edges (*Filter->Sketch->Torn Edges*), to name but a few. The mask can also be the basis for a layer mask, which we'll discuss in the next section.

7

LAYER MASKS

Photoshop's masking capabilities are even more flexible when used in conjunction with its layer features. A Layer mask is similar to a clipping path in that it acts like a cookie cutter on a layer, letting you see the layers underneath. But because it's a mask, its boundaries can be easily modified using Photoshop's painting tools.

Layer masks offer a productive way to perform compositing operations in which you seamlessly integrate one image into another. Compositing generally involves selecting a foreground object from one image and pasting it into another, so the two appear to be in the same scene.

ABOVE **A mask, like a clipping path, clips the outlines of the layer so you can see what's beneath it.**

3.

4.

Photoshop provides several ways to create layer masks. You can build on the technique described in the last section. Once you've created a mask:

1. Load the mask as a selection. However, instead of inverting the mask, leave the Invert option unchecked, so the selection applies to the post instead of the background. (You can always use the *Select->Inverse* option to toggle back and forth between foreground and background selection.)

2. Choose *Edit->Copy* (Cmd-C) to copy the post.

3. Open an image, such as the outer-space shot seen here.

4. Choose *Edit->Paste* (Cmd-V) to paste the post into the scene.

5. The post is pasted in place.

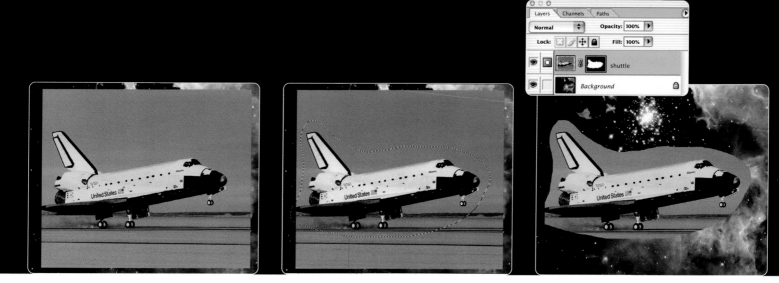

1.

2.

3.

Layer masks make compositing even more flexible because the entire foreground image remains "live" even after you've pasted it into the new scene. At any time, you can modify the edges of the mask to make parts of the foreground image appear or disappear. That's what we'll do in the next demonstration.

1. Begin with a photo of the space shuttle, which was pasted into the outer-space scene.

2. Draw a rough selection around the shuttle.

3. Instead of saving the selection, create a layer mask. Choose *Layer->Add Layer Mask-> Reveal Selection*.

4. Open the Channels palette as before, select the Mask layer, and use Photoshop's painting tools to refine it.

4.

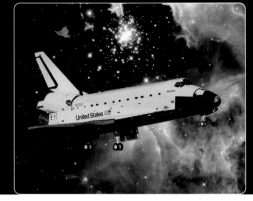

6.

7.

8.

Gaussian Blur

OK

Cancel

☑ Preview

100%

Radius: 3.0 pixels

5.

5. When you're happy with the new mask, apply a Gaussian Blur filter to blend the edges. This creates an effect similar to feathering.

6. The image is ready, or so we think.

7. Let's say the client doesn't like the wheels protruding from below the shuttle. Go back to the mask and paint out the wheels in the mask, using a soft brush to create a smooth edge.

8. Now the image is ready.

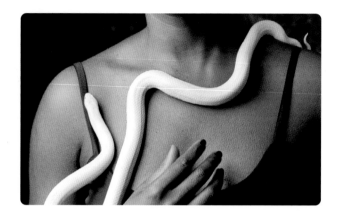

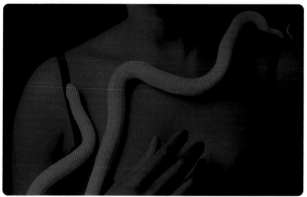

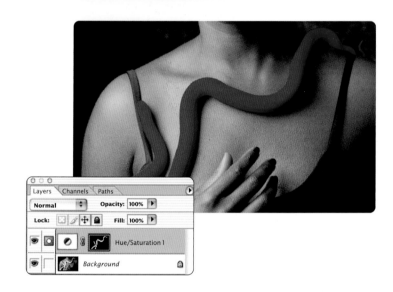

Using masks with special layer types

Just as you can apply a mask to an image layer, you can also apply it to other kinds of layers, such as adjustment layers. As you'll recall, an adjustment layer performs some kind of image-editing effect, such as changing Levels or Brightness/Contrast, on the layers below it. When you apply a Layer mask to an adjustment layer, the adjustment effects are limited by the mask's boundaries.

In the example here, we created a Hue/Saturation adjustment layer that colorizes the underlying black-and-white image. We used a Layer mask with the Adjustment layer to restrict the colorizing effect to the snake.

ABOVE **We used a mask in conjunction with a Hue/Saturation adjustment layer to create this colorizing effect.**

In the photo of the young ballerinas, we made a gradient fill layer (*Layer->Create Fill Layer->Gradient*) and chose Color as the layer blending option. Then we applied a mask of the girls' outline to the gradient layer, creating an island of black and white.

Using adjustment or fill layers makes the effects much more flexible, because you can easily modify the layer's characteristics. To change Hue/Saturation settings, choose *Layer->Change Layer Content->Hue/Saturation*. To change the gradient, choose *Layer->Change Layer Content->Gradient*.

LEFT **Here, we applied a mask layer to a gradient layer that colorizes the image. The mask layer restricts the gradient effect to the area around the ballerinas.**

Hints for Working with Masks

1. To create a new, blank layer mask, select the layer you want to apply the mask to and choose *Layer->Add Masking Layer->Reveal All*.

2. When you view masks in the Channels palette, only the layer mask for the currently selected layer will be visible and available for editing. To work on other layer masks, choose the associated layer in the Layers palette.

3. To temporarily remove a layer mask, choose *Layer->Disable Layer Mask*. You can then work on the portion of the layer hidden by the mask. Restore the mask by choosing *Layer->Restore Mask*.

4. To permanently remove a mask, choose *Layer->Delete Layer Mask*. You then have the option of discarding the mask or permanently applying it to the layer. If you choose the latter option, the layer is cropped into the shape of the mask, and any parts of the layer obscured by the mask are lost.

5. To reverse the masking effect so that the layer mask shields the foreground instead of background (or vice versa), select the layer mask in the Channels palette, then choose *Image->Adjustments->Invert* (Cmd-I). This creates a negative of the layer mask. It works like a toggle; to switch back, just hit Cmd-I again.

6. Remember that a mask is simply a gray-scale image and, in most ways, behaves like any other image in Photoshop. For example, you can cut and paste the contents of one mask—or image layer—into another (color images on an image layer will automatically convert to gray-scale when you paste them into a mask). You can use any tool that Photoshop provides for working with gray-scale images, including eraser, paintbrush, selection, and shape tools as well as many of the filters and image controls.

Compositing Tips

1. Compositing works best when the foreground and background images are shot under similar lighting conditions, with consistent shadows and highlights. An image with flat lighting will generally work better in a composite than one in which lighting angles are noticeable.

2. Work with the largest originals you can. Many compositing artifacts, such as rough edges between foreground and background layers, will disappear when the image is scaled down for use on the Web.

3. To help unify the appearance of foreground and background elements, try applying filters or other effects after an image has been composited. For example, the Lighting Effects filter (*Filter->Render->Lighting Effects*) can compensate for inconsistent lighting.

4. Use feathering or blurring to soften the edges of selection masks to improve blending between objects.

5. Compositing can be controversial in some situations, such as when *National Geographic* doctored a photo of the Egyptian pyramids so they could appear together on the cover. Use common sense here. If a photo is being used in a context where people expect it to be an accurate representation—such as in a newspaper article or courtroom exhibit—then modifying it with digital tools should raise ethical concerns. However, few would object to the use of compositing for artistic purposes, and compositing techniques are commonly seen in many areas of photography, design, and fine art.

< Creating Graphic Elements >

Although it originated as a photo-manipulation tool, Photoshop can create almost any kind of graphic element you can conceive of. In this chapter, we show how you can use Photoshop to create buttons, backgrounds, stylized titles, and other graphic elements. We spend much of the chapter discussing Photoshop's layer styles and layer effects, which are key to creating Web-design elements in a productive manner.

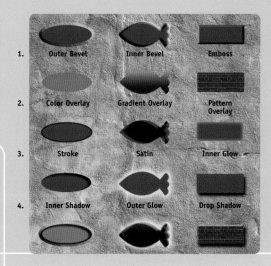

1.	Outer Bevel	Inner Bevel	Emboss
2.	Color Overlay	Gradient Overlay	Pattern Overlay
3.	Stroke	Satin	Inner Glow
4.	Inner Shadow	Outer Glow	Drop Shadow

1

LAYER STYLES

Photoshop's Layer Styles feature, a relatively new addition to the software, has proved a godsend for Web designers. Styles provide the basis for creating buttons, bordered backgrounds, and special type effects, and are especially useful for creating interactive elements with depth and photorealism. Adding a bevel or a drop shadow to a button, for example, gives it the look of a gadget that wants to be pushed.

Although Layer Styles work with any Photoshop layer, they are best used with layers clipped into some kind of shape. It can be a circle or rectangle, a more complex graphic made with Photoshop's painting or path tools, or a shape imported from a drawing program such as Adobe Illustrator or Macromedia FreeHand. They are commonly used with Shape Layers, in which the outline is a path, but also work well with Text Layers,

Layer Masks, or transparent layers on which you've painted a shape. However, many styles work best on the simplest shapes, and the layer itself need not have any content.

As you can see, Layer Styles can be built from any combination of ten effects: Drop Shadow, Inner Shadow, Outer Glow, Inner Glow, Bevel and Emboss, Satin, Color Overlay, Gradient Overlay, Pattern Overlay, and Stroke. You can also use blending options to modify the Layer Style's transparency. Once you've created a style, you can reuse it on any new layers you create, a great way to maintain a consistent look throughout a site.

LEFT **You can't tell from looking at them, but the three balloons were created using different techniques: shape layer (top), layer mask (middle), and simply drawing on a blank layer (bottom). We then applied layer styles to each balloon as well as the text.**

RIGHT **Layer Styles are built by combining layer effects. Each button on the bottom row was created from the four styles above it.**

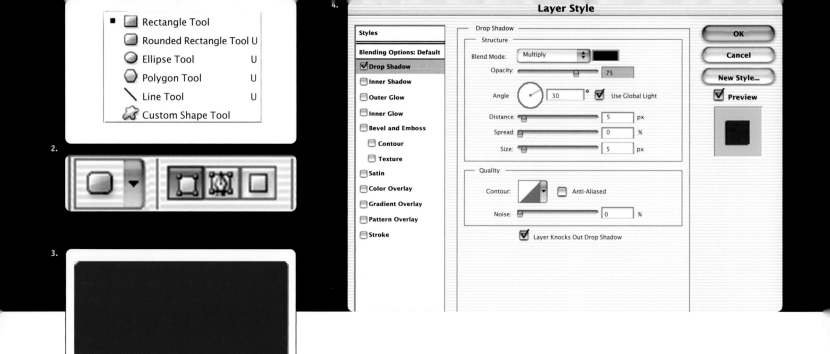

Creating a Layer Style

1. Open a new file (*File->New*). You can name it New Button.

2. There are several ways to create a shape layer; we take the easy route. Select the Rounded Rectangle tool from the Toolbox. Be sure the Shape layer option is selected in the options bar.

3. As you hold down the mouse button, drag from the upper left to lower right. You've created a shape layer.

4. The Layer Styles box features panes for each effect. We open it by choosing the Drop Shadow pane (*Layer->Layer Styles->Drop Shadow*). Here, you can change the shadow's settings, such as size, opacity, and distance from the layer. Click in the checkbox to turn the style on or off.

5. Now try activating the Bevel and Emboss effect. Again, you can modify the default settings. Use the Size control to modify the width of the bevel; the wider the bevel, the more the layer seems to rise from the surface.

6. Finally, we activate the Gradient Overlay effect. Instead of settling for the default gradient, we click on the arrow next to the gradient to choose a new one.

5.

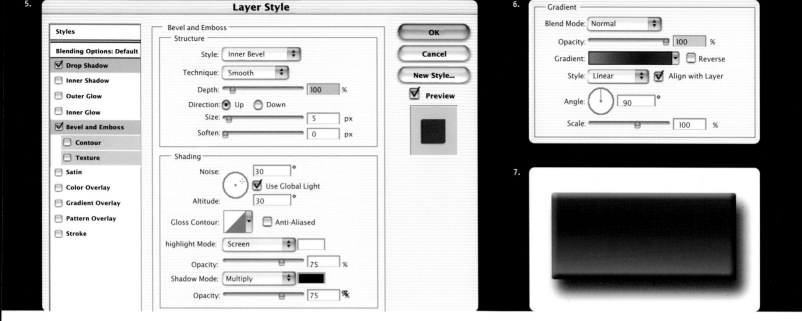

6.

7.

9.

7. Click OK to finish. The style appears on the shape layer.

8. Now we're ready to save the style. Open the Styles palette (*Window->Styles*). Click on the arrow to open the Styles menu and choose New Style. Photoshop will prompt you for a name. Enter one and click OK.

9. The style now appears in the palette.

The Styles palette also provides access to Photoshop's prebuilt styles, which provide a good starting point for building your own. Try randomly clicking on a few to see what effects they generate. You can then modify those effects to your liking. The prebuilt styles tend to be overused in Web designs, so try to be creative. However, keep in mind that a simple drop shadow or bevel can have a big visual impact.

LEFT **You can create a wide range of bevel effects by modifying the contour or adding textures. Here are six contour styles, each with a smooth inner bevel (left), a hard chisel inner bevel (center), and an emboss effect. The styles on the bottom include textures.**

RIGHT **You can choose from preset contour shapes in the Contour Picker.**

Fun with Bevels

You can further customize Photoshop layer styles by exploring the Bevel and Emboss options. Check Contour to modify the shape of the bevel effect and Texture to stamp in a pattern. Some options lend themselves to button elements, while others are best used for border effects. Try different combinations of bevel width, bevel style, and contour shape to see what works.

Transparency options provide another way to modify layer styles. In the bevel example here, we set fill opacity to zero, so the effect applies to the underlying layer.

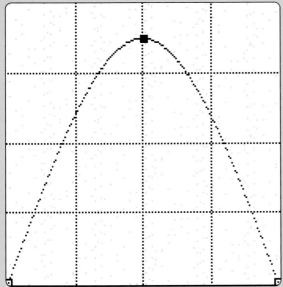

LEFT **You can edit the shape by clicking on the Contour icon.**

RIGHT **Textures selected here are embossed into the layer. You can use Photoshop's built-in patterns or create your own (see Seamless Tiles on page 117).**

Creating Shapes

The easiest way to create shapes for buttons and other graphic elements is to use Photoshop's shape tools to create Shape Layers. However, you can also create button shapes in other ways:

- Use a Dingbat font, such as Monotype Sorts, Webdings, or Wingdings. Each character in these fonts is a small piece of vector art. You can convert characters to shapes by choosing the *Layer->Type->Convert to Shape* command.

- Use Photoshop's path tools to modify existing shapes.

- Create shapes using Photoshop's painting tools. You can convert a solid, bitmapped object into a vector shape by selecting it with the Magic Wand tool, then choosing Make Work Path from the Path palette menu.

Type Effects

The same layer styles you use to create buttons and other elements also work with type. We created these type treatments (above left) by applying a range of layer effects to the text $E=mc^2$.

The "Fido" and "Boss" effects were achieved by applying a bevel to a type layer and then setting the layer's fill opacity to zero.

We created the effect on the right by using text to create a layer mask. We applied the mask to the top layer, which contained a negative of the bottom layer. We also added an Inner Shadow effect to the top layer.

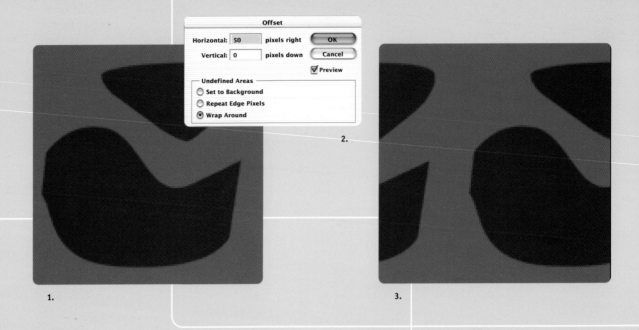

1.

2.

3.

2 TILED BACKGROUNDS

In addition to creating buttons and other graphic elements, you can use Photoshop to produce tiled backgrounds for Web pages. In the language of computer graphics, a tile is a small, rectangular image that's duplicated and arranged into a larger grid pattern. In Web design, tiled backgrounds provide one more way to achieve maximum visual impact with minimal file sizes. A tile measuring 100 pixels wide by 100 pixels high, when converted to GIF format, takes up just 9K to 12K of file space, depending on the number of colors.

The trick here is to create a seamless tile in which each edge matches up perfectly with the edges of adjacent tiles, creating the illusion of a continuous image. Photoshop provides several features that facilitate creation of seamless tiles, most notably the Offset filter (*Filter->Other->Offset*), which shifts the pixels in the tile, horizontally and vertically, according to numeric values that you enter. When you check the Wrap Around option, any pixels pushed off one side of the tile appear on the opposite side. The seams that would otherwise appear on the edges of the tile are now within its boundaries and can easily be removed with a little artistic flair.

4.

5.

6.

Creating a Seamless Tile

1. Create a new file measuring 150 pixels high by 150 pixels wide. Draw a shape to use as the basis for the tile. In this example, we leave room around the edges so we can add to the shape later.

2. Choose *Filter->Other->Offset*. We enter 50 for horizontal, which moves the image 50 pixels to the right (enter negative values to move in the opposite direction). Be sure the Wrap Around option is checked. Click OK.

3. Now the seam has moved inside the tile.

4. We paint inside the gap, filling in what once was the seam.

5. To test the pattern, we use Photoshop's Pattern Fill feature. When you're happy with the pattern design, choose *Edit->Define Pattern*. Enter a new name for the pattern if you want, then click OK.

6. Open a new file sufficiently big to tile the pattern, say 640 by 480 pixels. Choose *Layer->New Fill Layer->Pattern*. Enter a name for the new layer and click OK. By default, the last pattern you defined will appear in the window. If not, select it from the pattern chooser. Click OK, and the pattern you just defined will tile into the new image. You can then see how well it works as a seamless tile. This ability to quickly preview the tiled background is important because even with a seamless tile, you may need to experiment to get the most visually pleasing result.

You can also create seamless tiles that include photo-graphic effects. In our second example, we used two images from a larger photo of stones. We used the first image to create a tile measuring 200 by 200 pixels. We used the Offset filter to shift the image 100 pixels ver-tically and horizontally, moving the seam to the center of the tile. We then used the second image to create an overlay for the seam. This took care of the seam, but the tile wasn't quite right to use as a background. So we used Photoshop's Hue/Saturation control to darken and colorize the image, transforming it into the monochrome you see here.

Hue/Saturation

Edit: Master

Hue: 202

Saturation: 25

Lightness: -29

OK
Cancel
Load...
Save...

☑ Colorize
☑ Preview

TOP LEFT **A seamless tile.**

TOP RIGHT **For finishing touches, we use the Hue/Saturation control to colorize and darken the image.**

BOTTOM **The finished tile (left) and the pattern it creates.**

TOP LEFT **The Swirl filter from Alien Skin Software's Eye Candy 4000 is one of several third-party plug-ins that include a seamless tile option.**

BOTTOM LEFT **The Fur filter from Eye Candy 4000.**

TOP RIGHT **The Marble filter.**

BOTTOM RIGHT **Water Drops filter.**

Using Plug-ins to Create Tiles

In addition to Photoshop itself, several Photoshop plug-ins can produce seamless tiles. For example, some of the filters in Alien Skin Software's Eye Candy 4000 collection include a seamless tile option. As you can see, you can use them to create tile effects that would be difficult and time-consuming to create manually.

Pattern Maker

The new Pattern Maker in Photoshop 7 provides another way to create tiled backgrounds. You can select any part of an image to use as a background tile. When the Pattern Maker generates a tile, it modifies the pixels in edge areas to minimize the appearance of seams. You can generate—and save—multiple tiles, then scroll through the ones you've created using controls on the bottom of the screen.

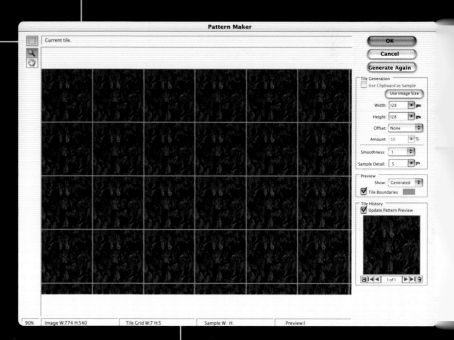

< Slices, Image Maps, and Rollovers >

So far, we've confined ourselves to the tools available in Adobe Photoshop. Now we turn to ImageReady, the companion program that allows production of more advanced Web effects. As we noted in chapter 1, Photoshop is geared toward the creation of static images, whereas ImageReady is designed for the production of images that include dynamic or interactive elements such as slices, image maps, rollovers, and animations. In this chapter, we cover slices, image maps, and rollovers, leaving animations for chapter 6.

Image slicing is the process by which you divide an image into rectangular slices. Each slice can be saved independently, with varying compression options, and each can be assigned a unique Web link and rollover effect. However, the sliced image appears in the browser as a single graphic element. Slicing is useful if you want to deploy an image as a navigation element or if you want to apply different optimization settings to each slice. Both Photoshop and ImageReady include features for creating slices, though the latter's are more extensive.

An image map is an image in which regions have been defined as hot spots—image map areas—with Web links or rollover effects. As with sliced images, image maps are useful for creating button bars and other navigation aids. There are two main differences: 1. Image slices are rectangular, whereas image map areas can be circular or polygonal, and 2. An image map is saved and downloaded as a single image rather than as a series of slices. Image maps are the exclusive domain of ImageReady.

A rollover is an animation effect that's triggered when you move the mouse or click over a button —or any other element—on a Web page. If the button includes a rollover, it might glow or change color. If it includes a secondary rollover, it could trigger the display of an additional graphic, such as a label or menu. Before you assign a rollover effect to a navigation element, the latter must be defined as either a slice or an image map. As with image maps, rollovers are left solely to ImageReady.

TOP LEFT **You can use sliced images as navigation elements (left) or in cases where you want to apply different optimization settings to different regions in an image (right). In the first image, we can apply unique URLs or rollover effects to each slice. In the second image, we can apply less compression to the top area to retain the sharpness of the text.**

BOTTOM LEFT **Image maps are great for creating button bars. Unlike slices, image map areas can be round or polygonal.**

BOTTOM RIGHT **Rollover effects cause controls to change appearance depending on mouse actions (left to right): no mouse action, mouse over, and mouse click.**

Create Slices from Guides

Duplicate Slice
Combine Slices
Divide Slide
Delete Slices
Delete All

Link Slices
Unlink Slices
Unlink Set
Unlink All

Promote to USer Slice

Arrange
Align
Distribute

Save Slice Selection
Load Slice Selection
Delete Slice Selection

Image Map tools — Slice/Slice Select tools

Image Maps Visibility toggle — Slices Visibility toggle
Preview Document — Preview in Default Browser

Jump to Photoshop

1 TWO PROGRAMS IN ONE

Photoshop and ImageReady share most tools and menu commands, and both provide features for slicing images and optimizing graphics for the Web. At first glance, ImageReady appears to be a carbon copy of Photoshop, sporting a Toolbox, Options bar, and most of the same palettes and menus. However, it adds a Slices menu for creating and managing image slices as well as several palettes not found in Photoshop: Animation, Rollovers, Image Map, Slice, Optimize, Color Table, and Layer Options.

The ImageReady Toolbox lacks Photoshop's path-editing tools and QuickMask feature as well as some of the painting tools, but it includes four Image Map tools along with controls that let you view (or hide) slices and image maps in the image. You can also preview rollovers and animations by clicking on the Preview Document or Preview in Default Browser buttons. The former lets you preview effects within ImageReady as they would appear in the Windows version of Internet Explorer. The latter displays previews within your default browser.

LEFT **ImageReady shares most of Photoshop's tools and menu commands but sports several palettes not found in its sibling: Animation, Rollovers, Image Map, Slice, Optimize, Color Table, and Layer Options.**

CENTER **The Slices menu provides access to ImageReady's extensive slice commands.**

RIGHT **ImageReady's Toolbox includes Image Map tools as well as controls that let you preview rollover effects.**

For the most part, a tool or command in ImageReady will behave the same way it does in Photoshop. However, ImageReady handles layer effects differently. When you choose a layer effect, such as Drop Shadow or Bevel and Emboss, its options appear in ImageReady's Layer Options palette rather than the Layer Style panel, as it does in Photoshop. For example, if you want to add or modify a drop shadow, the Layer Options palette transforms into a Drop Shadow palette that presents settings for that effect. In addition to the Layer Options palette—used to create or modify individual layer effects—ImageReady includes a version of Photoshop's Styles palette, where you save and apply preset layer styles that include a specific combination of effects. Unlike the Styles palette in Photoshop, ImageReady's version includes rollover styles that you can quickly apply to create canned rollover effects.

The two programs use different approaches to image optimization—the process of preparing images for deployment on the Web. In ImageReady, you optimize images through the Optimization and Color Table palettes, and you can preview them in the main window. This makes the program more productive because optimization features are available at all times. In Photoshop, you need to use the *File->Save for Web* feature to optimize and preview images. We discuss optimization in greater detail in chapter 7.

Photoshop and ImageReady are tightly integrated. Each includes Jump To commands that automatically launch the other program and open the current document. Depending on what kinds of graphics you want to produce, you can begin a project in Photoshop and then complete it in ImageReady, or take it from start to finish in either program.

LEFT **ImageReady provides access to layer effects through the Layer Options palette, which transforms into an Inner Glow palette when you choose the Inner Glow effect.**

RIGHT **In ImageReady, you can enter URLs for each slice in the Slices palette.**

2 WORKING WITH SLICES

Image slicing is useful if you want to assign unique URLs or rollover effects to multiple areas in an image. It also allows you to apply different levels of compression to different parts of an image. For example, if an image includes text, you can apply minimal compression to the text areas to retain sharpness and greater compression to other areas where quality is less important. Similarly, if you're slicing a GIF image, you can save each slice with its own limited color palette rather than using a single large palette of colors for the entire image. We discuss palettes and compression options in greater detail in chapter 7.

It's possible to combine image maps and image slices by assigning multiple hot spots to a single slice. However, you should not do this if the slice also includes a URL because some browsers are likely to ignore the links you've assigned.

Photoshop and ImageReady allow three kinds of slices: user slices, layer-based slices, and auto-slices. User slices are the kind you create with the Slice tool. Layer-based slices, as you might expect, are built from layers; they are best used for creating rollover effects. To define a layer as a layer-based slice, select it in the Layers palette and choose the *Layer->New Layer Based Slice* command. Photoshop automatically creates auto-slices in any area for which you haven't already defined a user or layer-based slice.

ABOVE **The Slice and Select tools.**

The Slice tool in Photoshop and ImageReady behaves much like the Rectangular Marquee tool. Simply draw a rectangle around each area you want to define as a user slice. You can also create slices from guides or rectangular selections, although the latter capability is available only in ImageReady.

Once you've set up your slices, you can assign unique URLs to each. Photoshop and ImageReady handle this in different ways. In ImageReady, you assign URLs using the Slice palette. In Photoshop, choose the Slice Select tool and double-click on a slice to bring up the Slice Options dialog box. Then enter the link in the URL field.

ABOVE **In ImageReady, you can enter URLs for each slice in the Slices palette.**

WORKING WITH IMAGE MAPS

3

As with slices, ImageReady provides multiple ways to create image maps. You can apply one of the Image Map tools or convert layers or selections into image map areas. If you want to create rollover effects, your best bet is to use layers because that typically makes the effects easier to set up. To create an image map area from a layer, just select the layer in the Layers palette and choose *Layer->New Layer-Based Image Map Area*.

Otherwise, you can choose from one of three tools for creating image maps: the Rectangle Image Map tool, the Circle Image Map tool, and the Polygon Image Map tool. The Rectangle and Circle tools work much like the Rectangular and Elliptical Marquee selection tools. Just click on the tool and drag it around the area of the image you want to define as an image map.

The Polygon Image Map tool works like the Polygonal Lasso tool, building the polygon as a series of line segments connected at anchor points. To use the tool, just click on an anchor point, move the mouse to the second anchor point, and click again. Keep adding anchor points until you've closed the polygon. You can reshape a finished polygon by dragging on the anchor points with the Polygon Image Map tool.

Once you've defined an image map, you can assign a URL through the Image Map palette. This works much like the Slice palette. Select a mapped area with the Image Map Select Tool and enter the link in the palette's URL field.

LEFT **ImageReady provides four Image Map tools.**

RIGHT **The Polygon Image Map tool lets you build polygonal image map areas by dragging from point to point.**

4 WORKING WITH ROLLOVERS

Rollovers have become common elements on Web sites because they are effective navigation aids. When you move the mouse over a button with a rollover effect, the button automatically draws attention to itself by changing appearance. If the button includes a secondary rollover, a menu or other object might appear elsewhere on the page. Rollovers are not limited to mouse-over actions; you can also set up effects in which clicking on an element, releasing the mouse button, or performing other actions causes it to change appearance.

When a browser displays a rollover effect, it does so by interpreting JavaScript commands, which are embedded in the HTML document. However, you don't need to learn JavaScript to create a rollover. Instead, you use ImageReady's graphics tools— particularly its layer functions—in combination with the Rollovers palette. When you export the image from ImageReady, the program automatically generates an HTML document that includes the JavaScript code needed to produce the effect.

ABOVE **Sample rollover effects. The first button represents the normal state, the second button a mouse-over state, and the third button a mouse-down or clicked state.**

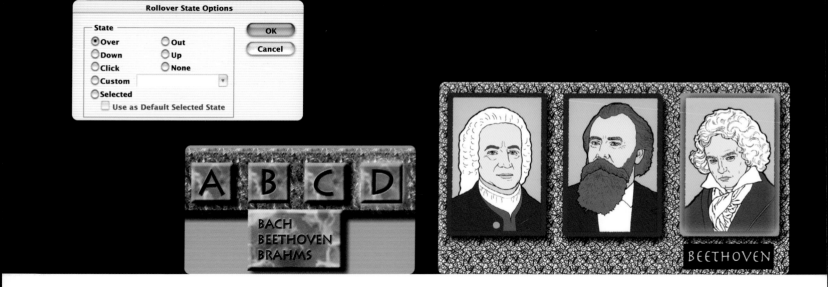

Rollover States

To create a rollover effect, you first determine how you want your navigation aids to appear in each different state, based on the mouse action. Then you use the Rollovers palette to assign each variation of the bottom to a different state. The default Normal state applies when there's no mouse action. In a common two-state rollover, you might add an Over state, in which the graphic glows and/or changes color when the mouse moves over it. Or you can set up a three-state rollover, in which the graphic shifts to a third color when the Web site visitor clicks or holds down the mouse button.

ImageReady lets you create rollover effects with up to eight different states, though it's rare that you'd ever want to use more than three or four. The other options are:

OUT The state that appears when the visitor moves the mouse outside the rollover area. Usually, this is the same as the Normal state, but using this option, you can set up rollovers to display a different image.

UP The state that appears when the visitor releases the mouse button over the rollover area. Usually, this is the same as the Over state, but again, you can use this option to choose a different image.

CUSTOM This state appears when a specific set of JavaScript commands is executed. You need to have some understanding of JavaScript to use this option.

SELECTED This state, a new feature of Photoshop 7, allows you to create complex rollover effects in which Web site visitors can select buttons and other navigation controls by clicking on them. When a button is selected, the appearance you define for this state remains active until the visitor selects a different button. In addition, any rollover effects you've defined for other buttons also remain active. For example, you can set up a secondary rollover in which selecting a button causes a menu to appear. The Web site visitor can move the mouse over other buttons, triggering Over actions such as an Inner Glow, but the menu will still appear until the user clicks on another button.

LEFT Rollover State Options in the Rollovers palette menu lets you choose from eight possible mouse states for each rollover effect.

CENTER The Selected state lets you build Web pages that can display two rollover effects simultaneously. When the Web site visitor selects the B button, the rollover displays a menu that remains on-screen even as the mouse moves over the D button.

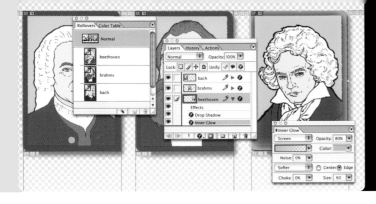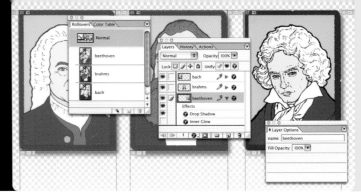

3.

Creating Rollovers

You can assign a rollover effect to any slice or image map area in an image. However, you'll generally find yourself working most productively if you use layers—and layer styles—as your building blocks.

We show how this is done for an imaginary Web site that has sections devoted to the three Bs of classical music, Bach, Brahms, and Beethoven. The site uses buttons depicting the composers to navigate to each section. We create a rollover in which moving the mouse over Beethoven's image causes the border around the button to glow. Then we add a secondary rollover that causes his name to appear on a dark background below the picture.

1. Create each button on a separate layer as you want it to appear in the Normal state. In our example, we use the Layer->Layer Styles command to add a Drop Shadow.

2. Select each layer and choose Layer->New Layer-Based Slice to define it as a slice. Here, we end up with three layer-based slices; ImageReady automatically generates additional auto-slices in the areas not covered by a layer.

3. Now we apply an Inner Glow layer effect that we later use in the Over state. The effect appears in the Layers palette; click on the eye icon in the visibility box to temporarily hide the effect.

4. Open the Rollovers palette. You'll see a list of each slice and image map area in the document. Click on the slice containing the Beethoven button.

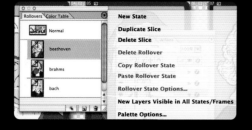

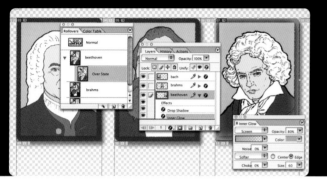

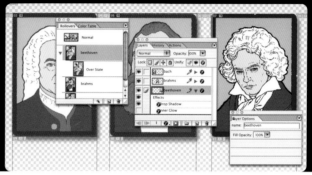

5.

6.

5. Choose New State in the Rollover palette menu, or
click on the Create rollover state icon on the bottom
of the palette. An Over state now appears in the
Rollover palette. You've now created the beginning
of a two-state rollover. When you click on
Beethoven in the Rollover palette, any changes you
make to any layer will appear only in the Normal
state. When you click on Over, any changes you
make will appear only when the mouse is over the
Beethoven button. To change Over to a different
state, choose Rollover State Options from the
palette menu.

6. With the Over state selected in the Rollovers
palette, we go back to the Layers palette and
click in the visibility box to activate the Inner
Glow effect. Now, in the Rollovers palette, click
again on the Normal state. The Inner Glow has
been deactivated.

7. At this point, we could continue adding rollover
states by repeating Step 5. Instead, we preview
the rollover we just created. Click on the Preview
Document button in the ImageReady Toolbox; this
displays the rollover in ImageReady as it would
appear in the Windows version of Internet Explorer.
If you've set up the effect correctly, the inner glow
should appear when you move the mouse over
the slice.

The Styles palette in ImageReady includes a collection
of ready-made multistate rollover styles that you can
apply to a slice or image map area. These styles are
identified by a black triangle in the upper left corner
of the style's thumbnail. You should avoid using them
if you want to create original designs, but they can
give you an idea of how rollovers are set up.

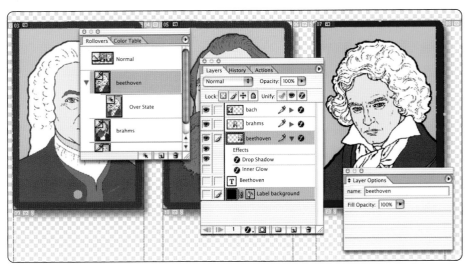

1.

Secondary Rollovers

You can create secondary rollovers in which moving the mouse over a button causes images to appear elsewhere on the page. Secondary rollovers are useful for presenting submenus, labels, and other elements that you don't want permanently placed on the page.

Here's an easy way to create a secondary rollover:

1. We created two new layers: a type layer containing the label Beethoven and a rectangular shape layer that serves as a background. We clicked in the visibility box to hide the layers.

2. We opened the Rollovers palette and selected the Over state for the Beethoven slice.

3. Back in the Layers palette, we clicked in the visibility box to make the text and background appear.

4. Use the Preview Document button to preview the effect.

Even though ImageReady provides tools for previewing the effects, you should also preview your finished work in Internet Explorer and Navigator on both the Mac and PC.

Once you've created your rollovers, you can export them by choosing ImageReady's Save Optimized As command. If you choose the Images and HTML option, the program will generate files in GIF or JPEG format for each slice in the image. In doing so, ImageReady also generates separate image files for each rollover state. These files are identified by a suffix matching the name of the state. For example, the image of Beethoven that appears in the mouse-over state would have a file name beethoven_over.gif. The file names are important, because some Web-authoring programs assume these naming conventions when setting up rollover effects. If you plan to export rollovers for use in GoLive, be sure to choose the Include GoLive Code option. This ensures that you'll be able to preview the rollover effects in the Web-authoring program.

We'll discuss ImageReady's output features in greater detail in chapter 7. But first, we'll look at the program's animation capabilities.

LEFT **The Styles palette in ImageReady provides access to ready-made rollover styles, which are identified by black triangles.**

RIGHT **We created a secondary rollover by adding two layers—a text label and a background—that appear in the Over state.**

< Creating Animations >

You see them on almost every Web site that includes advertising and even many that don't—blinking boxes that entice us to Click Here so we can learn about anything from a new software program to a credit card offer to an online dating service. They're animated banner ads, and creating them is a major source of business for Web designers working in Photoshop and ImageReady.

Banner ads are naturals for animation for two obvious reasons: They grab attention and they allow an advertiser to present a relatively large amount of information in a compact space because the message can be separated into smaller elements shown in successive frames. Because the ads typically consume a limited amount of screen real estate, file sizes for the animations can be kept small.

In this chapter, we cover the basics of creating animations in ImageReady, Photoshop's companion program for producing special Web effects. Although you can begin the animation process in Photoshop, ImageReady is where the action literally takes place. We focus on creating GIF animation, which remains the most popular format for animation on the Web. We also briefly cover Flash, the vector-animation format developed by Macromedia. Neither Photoshop nor ImageReady can produce Flash animations directly, but you can employ them to prepare files for use with programs designed to create Flash animations, notably Macromedia's Flash authoring software and Adobe's own LiveMotion.

1 FRAME BY FRAME

ImageReady is not a full-fledged computer-animation program. You certainly won't be using it to produce the next sequel to *Toy Story*. However, it does provide the essential tools you need to produce animated GIF files that run from a few seconds to a minute or more, depending on how you've set up the timing. ImageReady's Tween function, accessed through the Animation palette, makes it easy to set up animations where objects move around the screen or gradually fade from view.

You can set up animations to play once or to loop from the last frame back to the first. If you choose looping, you can set up the file to loop forever or a specified number of times. You can also set each frame to appear after a specified time interval. And you can combine animations with rollovers so that moving the mouse or clicking on a certain graphic element causes a different animation to play.

As with other forms of Web graphics, the challenge here is to get maximum visual impact in a minimum of file space. This is an especially important consideration when animating graphics because each frame in an animation can be a full-sized bit-mapped image. Fortunately, ImageReady's Animation palette includes an optimization feature that takes advantage of a unique capability in the GIF animation format. If you choose

Optimize Animation from the palette's menu, portions of the animation that don't change from frame to frame are rendered only once. This keeps file sizes small by confining each additional frame to areas in which movement occurs. The Optimize Animation feature is distinct from ImageReady's output optimization functions, which let you reduce file size by controlling compression and the number of colors in the image.

Like static GIF images, animated GIFs are limited to 256 colors and force compromises if you want to reproduce photographic subjects. ImageReady's GIF-optimization functions can yield good results with many photos, but only if you're willing to accept a full 256-color palette and relatively large file sizes. Another alternative is to use filters or other effects to convert a photo into an illustration that can be rendered with fewer colors. It all depends on the nature of the photo and what kind of look you are trying to achieve. We discuss these issues in greater detail in chapter 7.

Unlike with rollovers, you don't need special HTML or JavaScript code to produce the animation. All of the frames and instructions for handling them are contained within the file itself, which you can place on a Web page just like a static GIF image.

ABOVE **In this simple GIF animation, the text E=mc^2 blinks at specified intervals, then remains onscreen for ten seconds. Because the animation is optimized, the second frame is automatically cropped to remove areas it has in common with the first frame.**

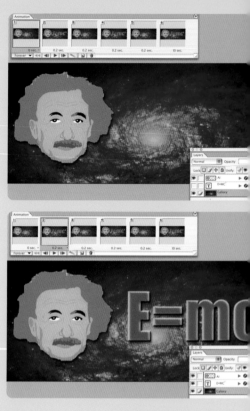

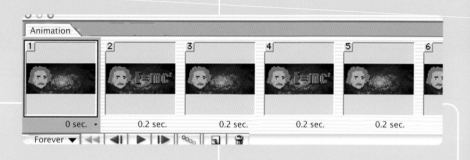

2 SETTING UP THE ANIMATION

Producing an animation in ImageReady is similar, in some ways, to producing rollovers. You work primarily in the Animation palette, which lets you add, move, delete, or choose individual frames or a range of frames. When you select a frame in the Animation palette, any changes you make to the Photoshop document are reflected in that frame only. For example, you can hide and show a Type layer in alternating frames to make it appear that the text is blinking.

When setting up an animation in either Photoshop or ImageReady, you should keep each element on a separate layer. You can then use ImageReady to animate each layer separately. Alternatively, if the animation is simple, you can set up each frame as a separate layer and use the Make Frames from Layers command in the Animation palette to automatically convert each layer into a separate frame.

VCR-like controls let you play back the animation or step through it one frame at a time. However, in most cases, the palette cannot match the animation's actual playback speed. To see how the animation will play on a Web site, you'll need to preview it in a browser. Achieving the ideal playback speed often requires a fair amount of trial and error.

LEFT **The Animation palette provides all the controls you need to set up and manage the animation, including looping options (lower left) and the time delay for each frame. VCR-like controls let you play back the animation or step through it one frame at a time.**

RIGHT **ImageReady's Layers and Animation palettes make for a productive combination. On the top, we used the Animation palette to select the first frame, then moved to the Layers palette to hide the Type layer by clicking in the visibility box. On the bottom, we selected the second frame, then used the Layers palette to reveal the Type layer.**

3 TWEEN

ImageReady's Tween function provides an easy
way to animate objects placed on separate layers.
You define the starting and ending points for an
object's position, opacity, or other effects, and
ImageReady automatically generates a series of
frames that show its gradual transition. You can
make objects move gracefully across the screen,
gradually fade in or out of view, or go through
layer-effect transitions, such as glowing or
changing color.

We used ImageReady's
Tween function to produce
this animation of a light-
bulb that glows increasing-
ly as it moves across the
screen. In the first frame,
we applied an Outer Glow
but set its size to zero. In
the last frame, we moved
the bulb to the right and
increased the size of the
Outer Glow to 30 pixels.
The Tween function then
generated ten intermediate
frames. In addition to
tweening movement and
layer effects, you can also
tween opacity, so that
objects gradually fade in
and out of view.

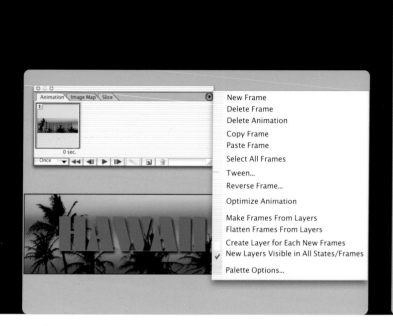

2.

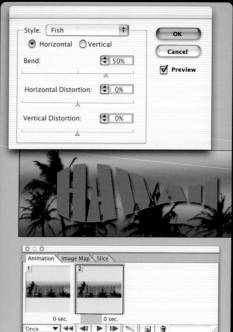

4.

You can also use the Tween function to animate type distortions, as we see here:

1. We begin with a tropical image, with the location Hawaii on a Type layer.

2. Choose New Frame from the Animation palette menu to add a second frame containing a copy of the current one. The new frame is automatically selected.

3. Now we want to warp the text in the second frame. Select the Type tool and click on the Type layer Hawaii in the Layers palette.

4. The Type Options bar should appear. Click on the Text Warp button and choose a warp style. We choose Fish.

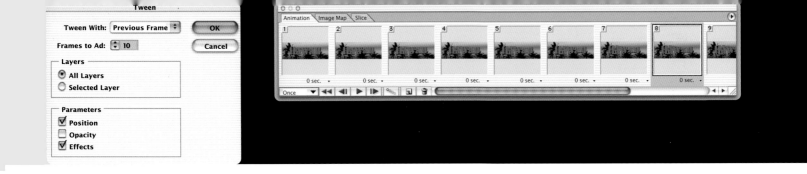

5.

6.

5. The type in the second frame is now distorted into the shape of a fish. To animate the distortion, choose Tween from the Animation palette menu. You can choose any number of frames to insert; higher numbers will produce smoother transitions but larger file sizes. For this example, we'll add ten frames.

6. ImageReady generates intermediate frames in which the text gradually distorts into a fish shape. Hit the Play button to play back the animation in the main window. Keep in mind that it will play back much more slowly in the Animation palette than it will in a browser.

4 FLASH ANIMATIONS

GIF animation is great if the animation is confined to a relatively small area. However, if you want to create more elaborate animation effects, your best bet is to use the Macromedia Flash format.

Flash is ideal for presenting full-screen animations consisting of text and other vector-friendly graphic elements. Instead of downloading a series of bit-mapped images, as you would with a GIF animation, the Flash plug-in downloads relatively compact instructions that determine how the graphics are presented. For example, to show a bouncing ball, the Flash plug-in downloads information that defines the ball's size and color, along with additional expressions that determine its position at certain points in the animation. In a GIF animation, you'd have to download a series of bitmapped images.

Although Flash is geared toward animating vector graphics, you can also incorporate bitmapped images, including photographs, with the animation. However, a Flash animation that includes bitmaps will tend to consume more file space than one consisting entirely of vector graphics.

Photoshop and ImageReady lack the ability to produce Flash animations directly. However, you can use them to prepare vector or bit-mapped images for import into a Flash-authoring program such as Macromedia Flash or Adobe LiveMotion.

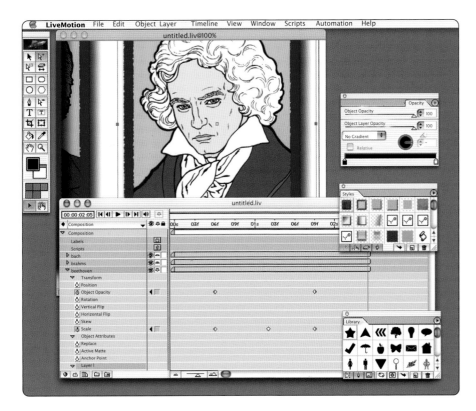

Both programs let you create animations by defining keyframes on a timeline. Each keyframe determines the starting and ending point for a certain object's behavior, but the capabilities here go far beyond what you can do with ImageReady's Tween function. For example, you can animate the size and rotation of objects in addition to their position and opacity. The timeline interface makes it easy to move keyframes from one time point to another. So, if you want an object to begin moving after three seconds instead of two, you simply reposition the keyframe within the timeline.

Flash and LiveMotion can both import Photoshop files directly. LiveMotion can recognize individual layers within the file, and you can convert each layer into a separate object that can be independently animated. Flash imports Photoshop files only as flattened images, and only if you have Apple's QuickTime software installed. A detailed explanation of these programs is beyond the scope of this book, but suffice it to say that Photoshop is a good companion for Flash animators, especially those using LiveMotion.

Now it's on to our final destination: producing images or animations for use on a Web page.

ABOVE **Adobe LiveMotion provides sophisticated keyframe-animation functions through its timeline. The program can import Photoshop files and treat each layer as a separate object, as shown here.**

Both programs simplify optimization by letting you view the original image next to previews of how it will appear with different compression or color-reduction options. This way, you can quickly judge how much a particular compression setting affects image quality. In Photoshop, you do this through the Save for Web feature. In ImageReady, you can preview images through the main program window. In addition to the previews, Photoshop and ImageReady will display each image's estimated download time at any given connection speed. If the image includes multiple slices, you can apply different optimization settings to each slice.

If you plan to compose your Web pages in Adobe's GoLive software, you can bypass this stage entirely and import native Photoshop files directly into the program. GoLive will recognize any slices, image maps, and URLs you've added to the image, and it even includes its own implementation of Photoshop's Save for Web feature so you can optimize images from within the Web-authoring program. However, if you want to bring rollovers or animations into GoLive, you'll need to use ImageReady's Save Optimized As function, which we describe later in this chapter.

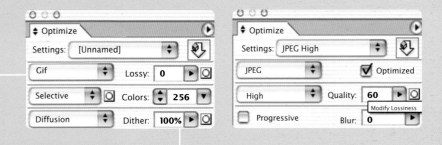

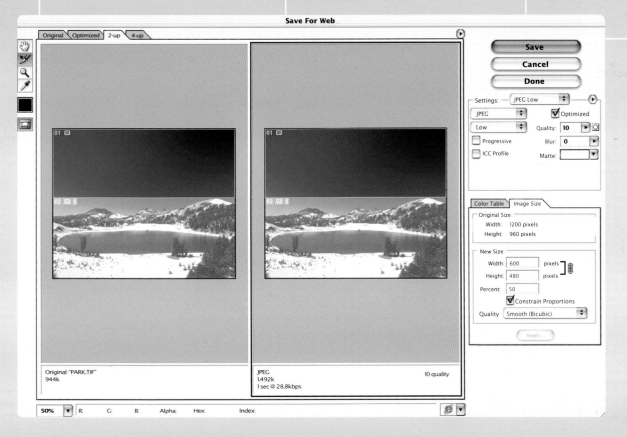

LEFT **Photoshop provides access to optimization functions through the Save for Web dialog box, where you can experiment with different combinations of settings and quickly see the results in the preview window. A pop-up menu atop the Settings panel lets you choose from canned settings for GIF, JPEG, and PNG images. You can begin by experimenting with these settings or define your own and save them to use again later. You can also use the Save for Web dialog box to view, select, and add URLs to image slices.**

RIGHT **ImageReady offers access to optimization functions through the Optimize palette. It displays different options depending on whether you choose to save the image in GIF (left) or JPEG (right) formats.**

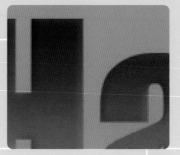

1 | SAVING JPEG FILES

If you're producing photographs or fine art, the JPEG format generally gives you the best image quality along with reasonably compact file sizes. JPEG uses lossy compression, meaning that it selectively throws away data in the image. You determine the amount of compression when you save the image. If you choose maximum quality, the software throws away just a little data, yielding a better-looking image but a larger file size. If you choose a low quality setting, the software throws away more data, generating a smaller file with a corresponding loss in image quality. A highly compressed JPEG image will display blocky artifacts, especially in areas with sharp edge detail.

As we noted in chapter 1, the compression setting is not the only factor that affects the image's file size. If an image has broad areas of similar colors, it will generally compress to a smaller size than one with fine color detail.

If you're working with a JPEG file, Photoshop and ImageReady will perform the lossy compression every time you save it, throwing away more data and further reducing image quality with each save operation. If you open an existing JPEG image, you should immediately save it in Photoshop or TIFF format before continuing. In general, you should save a file in JPEG format only once: when the image is ready to be placed on a Web page.

Photoshop and ImageReady both let you determine the amount of JPEG compression by entering numeric values—zero for lowest quality, 100 for highest—or by choosing one of four descriptive settings: Low (equivalent to a numeric value of 10), Medium (30), High (60), and Maximum (80).

In addition to applying different compression levels to image slices, you can set up Photoshop and ImageReady to apply higher quality settings in areas defined by alpha channels, vector shapes, or text layers. Just click on the mask icon in the Save for Web dialog box (Photoshop) or Optimization palette (ImageReady) to bring up the Modify Quality Setting dialog box. For example, by checking All Text Layers, you can apply a higher quality setting to any text that's in the image.

Aside from compression options, you can save JPEG files to download progressively in multiple passes, each with greater resolution than the previous one. This is especially helpful with large images because the visitor can get a rough idea of what they look like before the download is complete. Both programs also offer a blurring option, which can be useful if you want to smooth jagged edges or JPEG compression artifacts. If the image includes transparent elements, you can select a matte color that matches the background of the Web page; with a matte color selected, the edges along transparent areas will blend more smoothly into the background.

LEFT JPEG compression artifacts are especially noticeable in areas with sharp edge detail. The image on the left was saved at a low quality setting, the one in the center at a medium setting, and the one on the right at the maximum setting. All three images have been enlarged.

RIGHT The Modify Quality Setting dialog box lets you apply different compression settings to text, vector shapes, and areas defined by alpha channels.

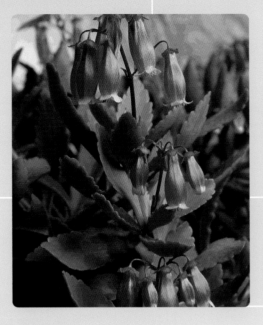 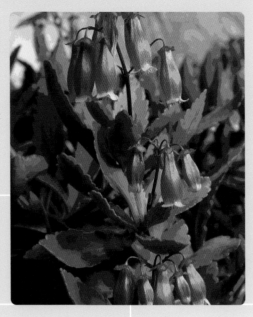

2 OPTIMIZING GIF FILES

GIF is the best format to use for type, logos, buttons, borders, backgrounds, and any other graphic element that requires sharp detail. As we've noted previously, it's the only format supported by Photoshop and ImageReady that can be animated. But it's also limited to 256 colors, and most images must undergo some form of color reduction before they can be saved in GIF format.

Photoshop and ImageReady let you choose from several color-reduction methods that map the colors in the original image to a new palette of 256 or fewer colors:

- The software can build a new palette based on the colors in the original image or those people are most likely to perceive, a method known dynamic color reduction. This generally yields the best results. You can choose from three options: Perceptual, Selective (the default), and Adaptive.

LEFT **This image was mapped to a 256-color palette using Photoshop's selective color-reduction technique, which generally produces the best results.**

RIGHT **This image was mapped to the Mac OS system palette.**

These gradients demonstrate the effects of color reduction and dithering. The first features a full spectrum with no color reduction or dithering. The second, reduced to thirty-two colors without dithering, displays discrete bands of color. The remaining gradients, also reduced to thirty-two colors, show the respective effects of diffusion, pattern, and noise dithering.

- The software can map the colors in the original image to a fixed palette, such as the 216-color Web-safe palette or the Mac or Windows system palettes. The problem here is that you can get big color shifts if the colors in the original image don't match up well with the selected palette.

- The software can map the original image to a custom palette in which you specify each color.

Once you've applied one of these color-reduction methods, you can use Photoshop's Web Snap option to convert colors in the image to the nearest Web-safe colors. If you set this to zero (the default), none of the colors are converted. If you set it to 100 percent, all of the colors will be converted to Web-safe colors. If you set a percentage in between, only those colors that are relatively close to Web-safe colors will be converted.

In many images, particularly photographs, any form of color reduction results in color banding effects. However, you can also apply dithering techniques to simulate additional colors and thus reduce banding. A dithered image on a computer screen is similar to a printed halftone; the software simulates a color it cannot otherwise display by creating a pattern from the existing colors.

As with JPEG images, GIF images can be set up to download in successive passes. Instead of checking the Progressive option, check Interlaced in Photoshop's Save for Web dialog box or ImageReady's Optimization palette.

Although GIF uses a lossless compression method, Photoshop and ImageReady both offer a lossy option that you can apply when saving GIF images. If you choose lossy compression, the software selectively removes data as it saves the image, resulting in a smaller file size. This lossy compression option for GIF is unique to Photoshop and ImageReady, which modify the image internally before generating the GIF file.

RIGHT **Dithering can reduce banding effects in photographic images, as seen here.**

3 GIF TRANSPARENCY

In some cases, you may know what kind of background your Web page will use, but other times, you won't. Either way, Photoshop and ImageReady provide extensive controls over background transparency, especially when producing GIF images. This allows buttons and other nonrectangular elements to seamlessly blend into the page—if you apply the functions correctly. Photoshop offers GIF transparency controls through the Settings and Color Table panels in the Save for Web dialog box, ImageReady through the Optimize and Color Table palettes.

If you know the Web page's background color, you can simply design all of your elements against a matching background and not fuss with transparency controls at all. However, this becomes a problem if the background color changes or hasn't been selected yet.

ABOVE **The easiest way to make your graphic elements transparent is to match the background color of the Web page in Photoshop, but that works only if you know the background color ahead of time.**

Using the Color Table, you can select one or more colors to be transparent; any pixels that match those colors disappear into the background. However, this technique doesn't allow for smooth transitions between foreground objects and the underlying page, so in many cases, you're likely to see jagged edges.

If you know the background color ahead of time, you can use the Matte option in Photoshop and ImageReady to create a smoother transition between foreground objects and the background. Simply click on the pop-up to choose a background color for the objects to blend against. If the background of the Web page changes, you can modify the matte color to match.

If your graphic elements include such transparency effects as drop shadows, you can use dithering options in Photoshop and ImageReady to simulate the effects against transparent backgrounds.

TOP **Using the Color Table, you can select one or more colors to be transparent.**

CENTER **The Matte option creates a smoother transition between foreground objects and the background.**

BOTTOM **You can use transparency dithering to simulate a drop shadow against a transparent background. The diffusion dither is shown here; you can also choose from pattern or noise transparency dithers in the Save for Web dialog box (Photoshop) or Optimize palette (ImageReady).**

4 OTHER FORMATS

Photoshop and ImageReady can save and optimize files in PNG and WBMP formats as well as GIF and JPEG. WBMP, short for Wireless Bit Map Protocol, is a standard for displaying graphics on handheld computing devices. PNG, which stands for Portable Network Graphics, is a relatively recent entry to the world of Web standards, and not all Web browsers support it. However, it has some advantages over GIF and JPEG. It comes in two versions: PNG-8 and PNG-24. The labels indicate the maximum number of colors permitted by the formats, as expressed in bits: 8 bits equals 256 colors, whereas 24 bits equals 16.7 million colors.

The PNG-8 format, though limited to 256 colors, uses a compression technique resulting in files that are about 30 percent smaller than equivalent GIF images. Like GIF, PNG-8 supports transparency. However, it does not support animation. Most of the color-reduction techniques you can apply to a GIF image can also be used with PNG-8 images.

PNG-24 combines the best features of GIF and JPEG. Like GIF, it uses a lossless compression technique that preserves sharp detail in an image, but, like JPEG, its color depth makes it suitable for saving photographs. However, files saved in PNG-24 format tend to be considerably larger than the equivalent JPEG files. As with its 8-bit sibling, PNG-24 supports transparency, but in a more powerful way than either GIF or PNG-8. When you define a transparent color in a PNG-24 image, it produces smoothly blended edges around the transparent areas rather than the jagged edges you're likely to see with the other formats.

5 SAVING OPTIMIZED IMAGES

Once you've optimized the image, it's ready for output. In Photoshop, you produce optimized GIF, JPEG, and PNG files by clicking on Save in the Save for Web dialog box. In ImageReady, you choose *File->Save Optimized As*. In both programs, you can save the image by itself or with the HTML code needed to display it in a Web browser. You should use the latter option when saving images that include slices, image maps, or rollovers. If the image is sliced, you can choose to save all of the slices or just those that you've selected with the Slice Select tool.

You can further customize the export by modifying the output settings in Photoshop and ImageReady. In Photoshop, the Output Settings option appears when you save an optimized file. In ImageReady, you access Output Settings through the File menu. Both programs include settings for generating HTML code, background images, file names, and slices. ImageReady provides an additional panel with output settings for image maps.

If the image is sliced, you can use the HTML output settings to determine how the slices are reassembled into a complete image. By default, the program generates HTML code that reassembles them as a table. The alternative is to reassemble them using a Cascading Style Sheet.

ABOVE **Photoshop's Output Settings panel lets you determine whether slices are reassembled as a table or a Cascading Style Sheet.**

6 WORKING WITH GOLIVE AND DREAMWEAVER

Adobe's GoLive software, from the same folks who brought you Photoshop, includes several features designed to facilitate collaboration between the two programs. Through the *File->Import* command, you can import native Photoshop files and have the layers automatically converted into floating boxes. But for the most efficient workflow, Photoshop users are advised to take advantage of GoLive's Smart Objects feature.

Here's how Smart Objects works: You drag a floating box from GoLive's Objects palette to the Web page. Then you drag a Smart Photoshop object from the same palette and place it within the floating box. When you import a Photoshop file into the Photoshop object, GoLive automatically opens its own Save for Web dialog box, allowing you to optimize the image or any slices contained within. GoLive then saves a special, optimized version of the image, which it uses on the page.

However, GoLive also maintains a link with the original Photoshop file. If you double-click on the Photoshop object, Photoshop automatically launches and opens the image. When you close the image in Photoshop, GoLive automatically applies any changes you've made and saves the image again using the original optimization settings. Most of this is transparent to the user. You double-click on the image, edit it in Photoshop, and see your changes automatically reflected back in GoLive.

If you want to bring rollovers into GoLive, you'll need to use ImageReady's Save Optimized As command to export the image(s) and the accompanying HTML/JavaScript code. Be sure you check the Include GoLive Code option.

Considering that Adobe and Macromedia are archrivals, it shouldn't be surprising that the latter company's Dreamweaver software lacks GoLive's extensive Photoshop support. It cannot import Photoshop files directly, though of course it can handle many of the formats that Photoshop produces, including PNG, GIF, and JPEG. If, for example, you want to use Photoshop to create a tracing template for use in Dreamweaver, you have to export the image in one of these formats.

By default, Dreamweaver uses another Macromedia product, FireWorks, as its external image editor. However, you can use Dreamweaver's Preferences panel to change the external editor to Photoshop. If you need to edit a GIF, JPEG, or PNG image in Dreamweaver, you can automatically launch Photoshop from within the program. When you're finished working your Photoshop magic, the image is automatically updated in Dreamweaver. However, unlike GoLive, Dreamweaver does not manage the production of optimized images.

CONCLUSION

Photoshop and ImageReady are complex pieces of software, and you can expect to spend considerable time mastering them. However, you don't need to be a Photoshop master to use the program productively. Many experienced users have barely touched half its features, and there's much you can do with even a rudimentary understanding of its features.

The most effective way to learn a program like Photoshop is to begin with a relatively simple project and absorb just what you need to complete it. You can then move on to more difficult jobs, picking up additional knowledge about the program along the way. Plenty of help is available in the form of conferences, courses, fellow users, and, of course, books like this. One of the best places to find tutorials and other information is the Adobe Systems Web site. Ultimately, what you need is a design idea and a willingness to dive in and experiment. Photoshop will take care of the rest.

< Glossary >

Adjustment layer. A Photoshop layer that performs a specific image-processing operation on the underlying layers.

AltiVec. An extension to Motorola's PowerPC G4 CPU that speeds processing of certain kinds of instructions. Also known as Velocity Engine.

Alpha channel. A channel in a Photoshop file used to store a mask.

Animated GIF. A GIF file that is animated through the incorporation of multiple frames that play one after the other.

Antialias. An image-processing effect in which areas along the edges of text or other objects are slightly blurred to create a smoother appearance.

Aqua. The graphical user interface in Apple Computer's Mac OS X operating system.

Background layer. A nontransparent Photoshop layer that lies underneath all other layers. When you open an image in Photoshop, it automatically appears on a background layer.

Bevel. In Photoshop, an image-processing effect that makes a layer appear to have contoured edges.

Bitmapped graphics. Photographs and other digital images stored internally as arrays of dots.

Blend mode. An option in Photoshop that lets you determine how a painting tool or layer interacts with the underlying image.

Browser. A program that lets computer users view a Web site.

Cathode ray tube (CRT). A display technology that uses bulky monitors similar to those in most television sets.

Central processing unit (CPU). The main processor in a computer system. Examples include Intel's Pentium and Motorola's PowerPC.

Channel. A component in a digital image used to store a primary color or mask. In an RGB image, the red, green, and blue primary colors are stored in separate channels.

Classic environment. The part of Apple Computer's Mac OS X operating system that lets you run programs designed for previous versions of the Mac OS.

Client. A computer used to access information on a Web or network server.

Clipping path. In Photoshop, a path that defines the outer boundaries of a layer or image.

CMYK. A color space, most often used in commercial print production, that defines colors as different percentages of cyan, magenta, yellow, and black.

Color management. A technique used to ensure consistent, accurate reproduction of colors across different monitors and output devices.

Color space. A model used to define the primary components of color. Examples include RGB, CMYK, and Lab.

ColorSync. A color-management system developed by Apple Computer and included in the Macintosh operating system.

CompactFlash. A flash memory format used to store digital images in some digital camera models.

Compositing. The process of combining multiple images into a single picture.

Continuous-tone image. An image in which the tone or intensity of each dot can be varied. Most traditional photographs, as well as images displayed on a computer, are continuous-tone images.

CPU. See Central processing unit.

CRT. See Cathode ray tube.

Dithering. An image-processing effect used to simulate colors that otherwise cannot be displayed on a particular computer system. The colors are simulated by arranging dots of colors the computer can display, such as blue and red to simulate purple.

Extensible Markup Language (XML). A popular format for defining the presentation of documents on the Web. Offers greater flexibility than HTML.

Filter. A Photoshop plug-in that modifies pixels in an image or adds new pixels to create a particular effect.

Flash. A popular vector-animation format developed by Macromedia. Flash files are identified by the extension .swf.

Flash memory. A storage technology, popular in digital cameras and handheld computing devices, that uses semiconductors (computer chips) to record data. Examples include CompactFlash, SmartMedia, and Memory Sticks.

Frame. 1. An individual image within an animation. 2. A window used to organize information on a Web site.

Gamma. A numeric value that defines the overall brightness of the displays.

GIF. See Graphics Interchange Format.

Gradient. A fill pattern in an image that presents smooth gradations from one color to another.

Graphics Interchange Format (GIF). A popular graphics file format used on the Web. GIF images are limited to 256 colors.

Halftone. An image that uses an array of dots to simulate a continuous-tone image. Images printed in newspapers, books, and magazines are halftones.

Hexadecimal. A value that uses combinations of six letters and numbers to define colors in an HTML document.

Highlights. Light parts of an image.

Histogram. A graph that displays information about the distribution of highlights, shadows, and midtones in an image. Each tone is represented by a single vertical line, the length of which indicates the number of pixels matching that tone.

HSB. A color space that defines colors as combinations of hue, saturation, and brightness values.

HTML. See Hypertext Markup Language.

Hypertext Markup Language (HTML). A standard coding system used to define the appearance of Web pages.

Image map. A single image that includes multiple links to other Web pages.

Indexed Color. A color mode in Photoshop that limits the palette to a certain number of fixed colors.

Interpolation. A technique that increases the apparent resolution of an image by inserting new dots between existing ones. Photoshop applies an interpolation technique when you enlarge an image past its original size.

Java. A popular programming language used to develop content on Web sites.

JavaScript. A scripting language, easier to learn than full-fledged programming languages, used to develop content on Web sites. Rollovers created in Photoshop are stored in JavaScript code.

JPEG. A popular file format used to store photographs and other images presented on the Web. JPEG is an acronym for Joint Photographic Experts Group, the body that developed the format.

Keyframe animation. A technique in which animations are created by defining the starting and ending points for an action. The animation software automatically generates the intermediate frames.

Lab. A color space that defines colors through a simulation of human visual perception.

Layer. In Photoshop, the basic building block of an image.

Layer mask. A mask that defines the outer boundaries of a layer.

Layer style. A set of effects, such as bevels and drop shadows, that can be stored and applied to layers in a Photoshop file.

LCD. See Liquid crystal display.

Liquid crystal display (LCD). A flat-panel monitor technology that's an alternative to the bulkier cathode ray tube (CRT).

Loop. An animation that plays continuously by starting over when it reaches the last frame.

Luminosity. The tonal characteristics of an image, separated from color. You can see the luminosity of a color image by converting it to grayscale.

Mac OS 9. A version of the Macintosh operating system introduced in 1999. Also known as the classic Mac OS.

Mac OS X. Apple Computer's latest operating system.

Mask. A grayscale image that acts as a stencil on the image underneath it. Masks serve multiple functions in Photoshop.

Megapixel. A unit, equivalent to one million pixels, that describes the resolution of a digital camera.

Memory Sticks. A flash memory format from Sony used to store images in many of the company's digital camera models.

Midtones. The tones in an image that fall between highlights and shadows.

Moiré. A gridlike distortion that appears when a halftone is scanned and printed on an offset press.

Multiprocessing system. A computer system that includes multiple CPUs.

Multitasking. A technology that allows multiple software programs to simultaneously share the resources of the CPU.

Optimization. In Photoshop, the process by which you modify an image's color palette or compression settings to achieve a satisfactory balance between file size and image quality.

Options bar. A bar in the Photoshop workspace that lets you set options for the currently selected tool.

Palette. 1. The range of colors in a particular image. 2. A movable window in Photoshop that provides controls for certain kinds of functions.

Path. A graphic element composed of lines and curves, the size and shape of which are defined by anchor points and control points. Also referred to as a vector graphic.

PDF. See Portable Document Format.

PICT. A graphics file format developed by Apple Computer.

Pixel. A dot that represents the fundamental element of a digital image. The term is a contraction of *picture element*.

Plug-in. Software that extends the capabilities of Photoshop and other programs.

PNG. See Portable Network Graphics.

Portable Document Format (PDF). A popular file format developed by Adobe Systems that can be used to exchange documents that include typography and images. The technology is also known as Acrobat, which refers to the software used to create or view PDF files.

Portable Network Graphics (PNG). A standard image format used on the Web.

Preemptive multitasking. A sophisticated form of multitasking used in modern operating systems such as Apple Computer's Mac OS X.

Primary colors. A limited set of colorants that can be mixed in various percentages to create a wide range of colors in print or on an electronic display.

Profile. In color management, a file that contains information about the color reproduction characteristics of specific monitors, input devices, and output devices.

Protected memory. A feature in Mac OS X and other modern operating systems that causes each program to run in a separate area of memory. One benefit is that a program will not freeze the entire system if it crashes.

RAM. See Random access memory.

Random access memory (RAM). The main memory in a computer system.

RGB. A color space used in computer displays that defines colors as varying percentages of red, green, and blue.

Rollover. A popular Web-design effect in which moving the mouse over an element causes other elements to appear, either in place of that element or elsewhere on the page.

Saturation. The purity of color in an image. Saturated colors appear vivid; desaturated colors appear grayed out.

Scalable Vector Graphics (SVG). A vector graphics format based on the Extensible Markup Language.

Seamless tile. A tile whose edges seamlessly blend with those of neighboring tiles so that they appear to be part of a single image.

Server. A computer system that serves as the hub of a network, either locally or on the Web.

Shadows. Dark areas in an image.

Shape layer. In Photoshop, a layer whose boundaries are defined by a clipping path.

SmartMedia. A flash memory format used to store digital images in some digital camera models.

SVG. See Scalable Vector Graphics.

TIFF. A popular file format for storing photographs and other bitmapped images.

Tile. A small rectangular image that can be repeated in a grid to create a larger image, such as a background.

Transparency grid. In a Photoshop file, a checkerboard pattern that you see when all layers are transparent.

Universal Resource Locator (URL). An Internet address that identifies the location of a Web page.

Unsharp Mask. A technique for increasing sharpness in an image. In Photoshop, it's implemented through the Unsharp Mask filter.

URL. See Universal Resource Locator.

Vector graphics. Graphics defined as a combination of lines and curves, which are stored internally as mathematical expressions. Also referred to as object-oriented graphics.

Velocity Engine. Apple Computer's brand name for AltiVec, an extension to the PowerPC G4 CPU that speeds processing of certain kinds of data.

WebDAV. A standard protocol for transferring files, including Photoshop files, to and from a production server.

Web-safe palette. A group of 216 colors that can be displayed without dithering on any color monitor. Each color is defined in an HTML document by a unique hexadecimal value.

XML. See Extensible Markup Language.

< **About the Author** >

Stephen Beale has been writing about computer graphics since 1987. He is the former news and reviews editor of *Macworld* magazine, a regular contributor to *HOW* magazine, and the author or coauthor of seven books on computer graphics and desktop publishing.